DUNSTABLE
THROUGH TIME
John Buckledee

AMBERLEY PUBLISHING

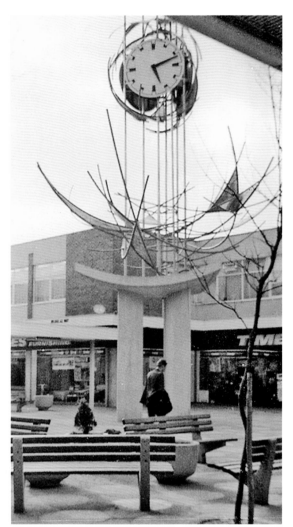

Front cover top: One of the first photographs taken of Dunstable, showing the old town hall in High Street North – not the one demolished in 1966, but the previous building on the site, which burned down in 1879. It had originally been a market hall owned by the Crown and was purchased by the newly created Dunstable Borough Council to provide a town hall in 1866. The clock tower was added in 1869, which enables the photograph to be dated to within ten years.

Front cover bottom: High Street North in Spring 2014, with the Santander Bank building on the town hall site.

Left: The Quadrant shopping centre clock, erected in 1966 on a network of metal rods incorporating translucent coloured panels. It was taken down in 1987.

First published 2014

Amberley Publishing
The Hill, Stroud, Gloucestershire, GL5 4EP
www.amberley-books.com

Copyright © John Buckledee, 2014

The right of John Buckledee to be identified as the Author of this work has been asserted in accordance with the Copyrights, Designs and Patents Act 1988.

ISBN 978 1 4456 3808 9 (print)
ISBN 978 1 4456 3826 3 (ebook)

British Library Cataloguing in Publication Data.
A catalogue record for this book is available from the British Library.

Typesetting by Amberley Publishing.
Printed in Great Britain.

Introduction

Dunstable, once a centre for stagecoach travel and then a major base for hat making, has emerged from a series of giant upheavals over the centuries, and this book provides many examples of history repeating itself.

Until recently, the town had thriving factories based on vehicle manufacture, engineering and printing. These have all now closed. This has happened at a time when the general growth of supermarkets and internet shopping has been taking customers away from traditional high street businesses, and the town centre (astride two major transport routes) is almost continually clogged by traffic.

This book, containing photographs of old Dunstable matched with corresponding views of the scene today, reflects the town's changing fortunes. Nearly all the pictures taken in early 2014 show the town in transition, with many examples of rebuilding and renovation. New workplaces are emerging, and leisure and service businesses have sprung up. A host of new facilities have been provided amid historic buildings and attractive housing. Perhaps this book will be seen in the future as reflecting another watershed in the town's history.

Dunstable Through Time has been compiled by John Buckledee, who produces the weekly Yesteryear feature in the *Dunstable Gazette*. He is a former Editor of the *Dunstable Gazette* and *Luton News* and chairman of the Dunstable & District Local History Society. He edited reprints of three rare books about Dunstable: *Dunno's Originals*, *The Dunstaplogia* and W. H. Derbyshire's history of the town. His major articles include accounts of medieval tournaments in Dunstable, film star Gary Cooper's Dunstable connections, the Wicked Lady of Markyate, Dun the Robber and Dunstable in the First World War.

Acknowledgements

The collection of old photographs in this book was originally assembled, digitised and researched as part of the weekly Yesteryear feature in the *Dunstable Gazette*. The series has been running for decades and remains a popular part of the paper. At first, most of the Yesteryear pictures were retrieved from the drawers of old desks in the *Gazette* office and from envelopes left in the backs of cupboards and bookshelves – flotsam that generations of journalists had been reluctant to throw away. But then, readers sent in souvenir postcards and photographs from family albums, and in recent years further prints have been made from the *Gazette*'s precious negatives, stored in the museum at Wardown Park, Luton. Nearly all the pictures in this book are from those sources. Names of readers who contributed are mentioned in the captions to individual pictures.

Particular thanks are due to Chris Grabham, who has had special responsibility for the care of photographs in the museum, and to the *Gazette*'s former sub-editor, David Ainsbury, who has made it his mission, before and after his retirement, to discover what has been lying hidden in those archives. The town has been fortunate over the years to have had its events covered by a series of dedicated professional photographers, most of whom worked for the *Gazette* as staff photographers or freelancers. Let's mention, for example, Charles Smy, Bruce Turvey, George Gurney, Mike Dellow, Harry Dobkin, Roy Bushby, Mick Hawes, Spike Godfrey, Russell Baker, John Shorthouse, Gareth Owen, Andy Wright, Julie Harper, Mark Richards, Nigel Wigglesworth, Mike Pierce, Jo Cross and Jane Russell. Any collection of Dunstable photographs is bound, sooner or later, to include examples of their work.

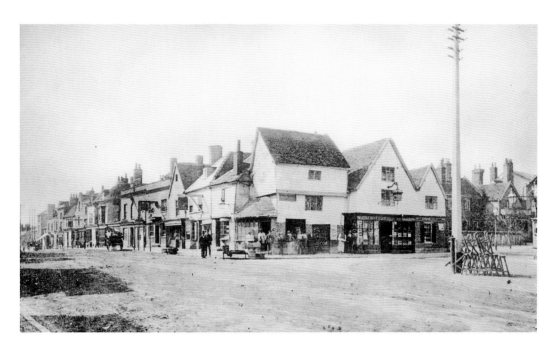

Middle Row Before Widening

The motley collection of shops and businesses known as Middle Row has grown in higgledy-piggledy fashion over the centuries and now has a particular charm, despite being in need of a great deal of tender loving care. This famous photograph was taken at the crossroads around 1890. The buildings in the foreground were demolished in February 1911, leaving the old Rose and Crown pub, whose sign can be seen in the photograph, to become the corner building on West Street. There is another pub sign visible a little further down the road. This would have been for the Britannia, alongside the tunnelled alleyway, which burned down a few years after the photograph was taken.

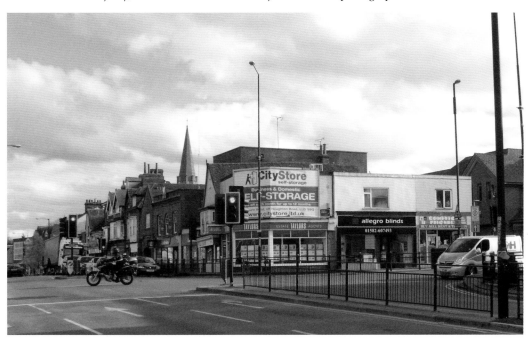

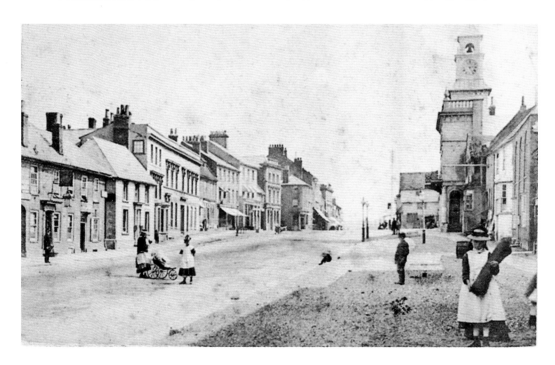

Town Hall Burned Down

A youngster in boots and a pinafore, carrying what appears to be a rolled-up carpet, stands perfectly still to enable Victorian photographer F. S. Mills to take this photograph of High Street North, Dunstable. The White Hart coaching inn is on the left. The original of this picture is a tiny snapshot, mottled with age, which was discovered by James Empson, of Ipswich, among his parents' possessions. The town hall in the photograph burned down in 1879, just ten years after the clock tower was added to the building.

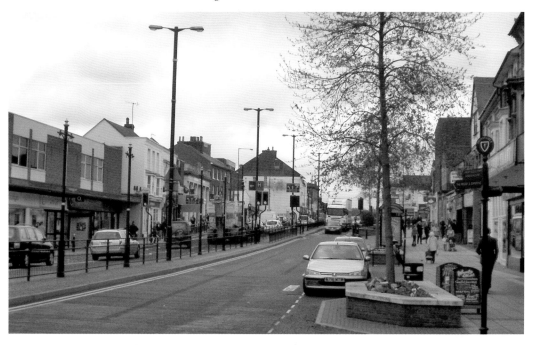

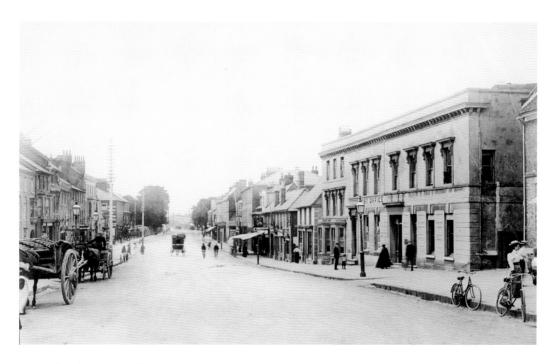

The First Post Office

Dunstable's original post office dominates this view of High Street North, looking from the crossroads, with the old White Hart further down the road. The inn was later replaced by a modern pub, which was in turn demolished when the Quadrant shopping centre was built. The signage for the *Dunstable Borough Gazette* office and printing works is just visible, in the distance, on the corner of Albion Street. The post office moved to purpose-built premises almost opposite Grove House around 1913.

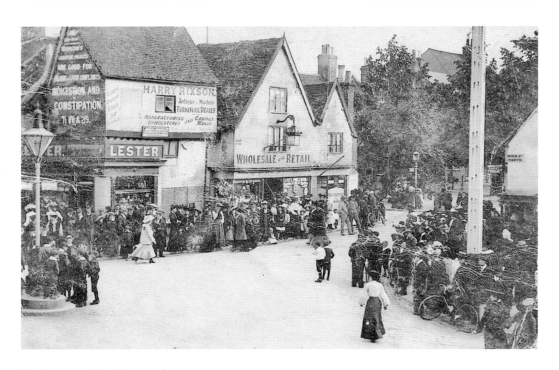

Gas Lamp on the Crossroads

Crowds line the pavements around Dunstable crossroads in this very early (and now rather creased) photograph. It shows the shops at the end of Middle Row, on the corner of High Street South, which were demolished around February 1911 to allow West Street to be widened. Fascinatingly, the photograph shows the raised area around the gas lamp that once stood at the centre of the crossroads and was the focal point for numerous gatherings. Gas was first used for street lighting in Dunstable in 1836. The photograph belongs to Miss Christina Scott.

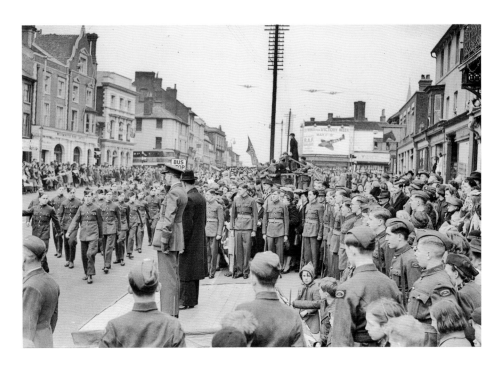

Snap ... as the Bombers Fly Over

Long before digital cameras were invented, press photographers had just one chance to take a crucial picture, using single negatives made of glass plate. So the *Gazette* photographer would have been immensely proud of this 1943 picture, for which he had to be in precisely the right place at the right time. The scene was a parade down High Street North for 'Wings for Victory' week. The photographer included a giant Spitfire poster on Keep's Corner and he pressed the shutter just as three RAF bombers flew towards the town centre.

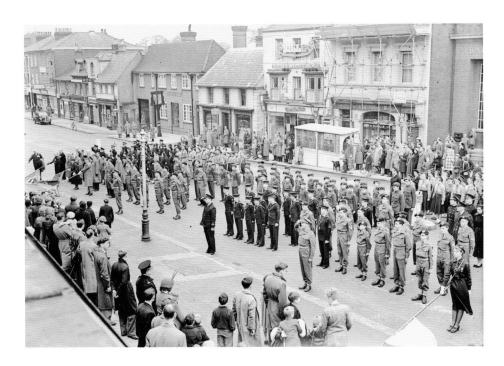

On Parade in the High Street

High Street North was closed to traffic for this Remembrance Day parade outside the old town hall in the 1950s. In the foreground are members of the Dunstable Grammar School Combined Cadet Force, seen behind their commanding officer, Capt. R. F. Broadfoot. Shops in the background include the Confectionary Bazaar, once famous for its Kunzle cakes, and the White Hart pub, demolished to make way for the Quadrant shopping centre. One building that survived was Charlie Cole's cycle shop, now the home of the Nationwide Building Society.

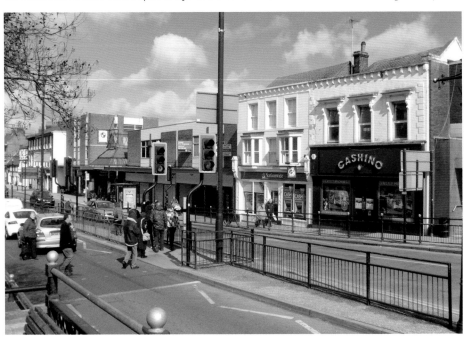

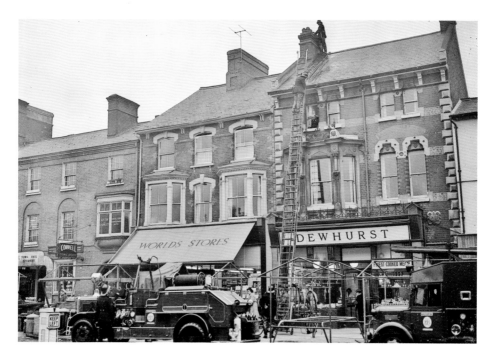

Chimney Fire at the Butcher's

A routine job for firefighters, in the days when homes and businesses were heated by coal fires, was tackling blazes when soot in the chimney caught fire. The firemen would climb on to the roof and hose water down the chimney. It was a messy business! This typical scene was in High Street North, in March 1958, when there was a chimney fire in the butcher's shop owned by Dewhurst's. The buildings in this part of Dunstable remain virtually unaltered today, although the owners have changed.

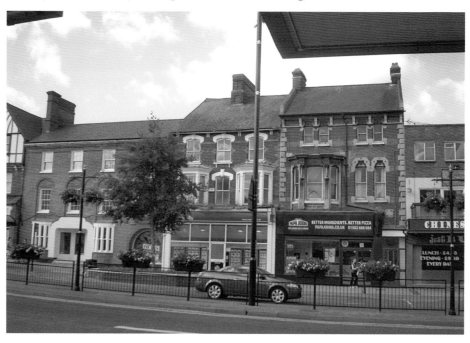

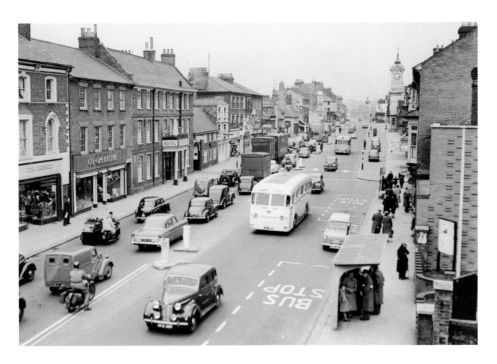

The Old Clock Tower

The photographer stood on a metal stairway in the Union Cinema in the early 1950s to take this picture of High Street North. The cinema, after periods as a bingo hall and a nightclub, has now been beautifully restored by its present owners, the Dunstable Community church. The clock tower of the town hall, demolished in 1966, can be seen in the distance on the right. Note the convenient parking spaces on the side of the road. These were not available on market days, Wednesdays and Saturdays, when they were used for stalls.

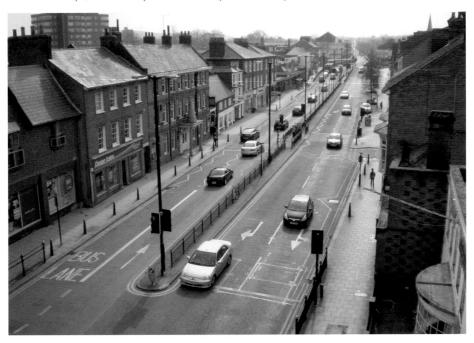

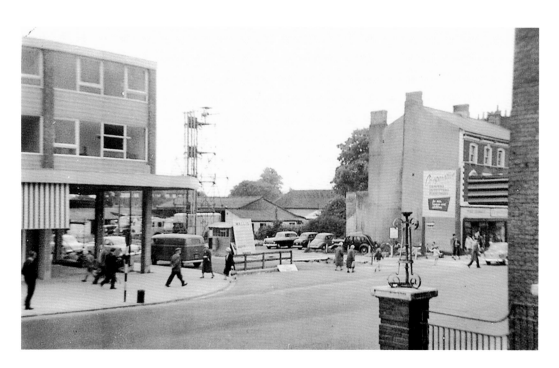

Entrance to the Fire Station

A new road (to be called Queensway) was still fenced off when this photograph was taken in 1961, but the new shops on its north side were already open. Martin's, the newsagent, is on the corner of High Street North and Queensway, and the old Co-op department store is on the other side of the junction. The scaffolding of Dunstable fire station's hose tower can be seen at the rear of the Co-op. The fire station was situated there for many years in temporary buildings alongside the track, but moved to Brewers Hill Road in 1965.

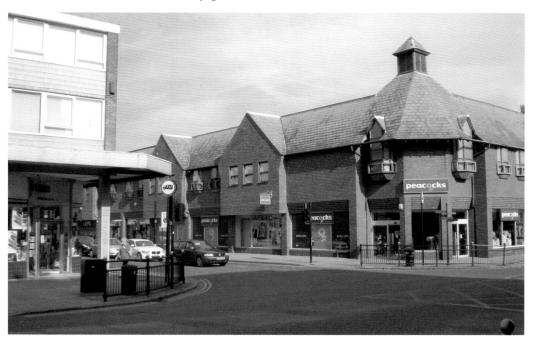

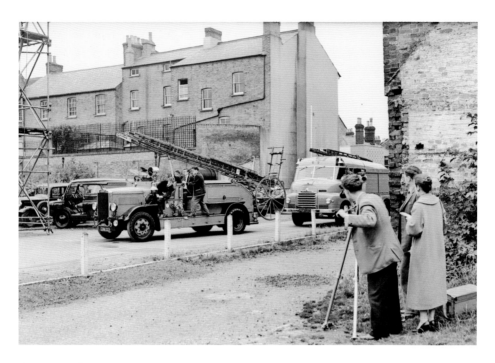

Filming in the Future Queensway

A film crew was in Dunstable in 1956 to make a documentary called *The Way Ahead*. It featured pupils from Dunstable Grammar School taking part in a newly created youth awards scheme set up by the Duke of Edinburgh. The boys were seen on a fire engine driving down Drovers Way and then travelling down the little road that led to the old Dunstable fire station (*pictured*). The route, which later became Queensway, continued past some allotments and wartime huts. The rear of the old Co-op department store can be seen in the background.

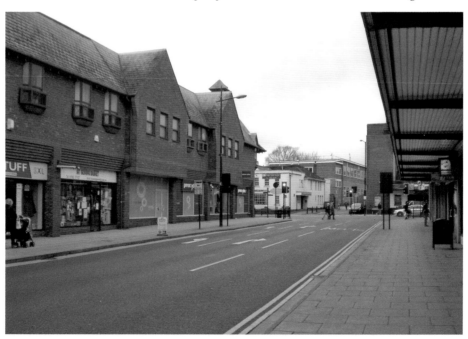

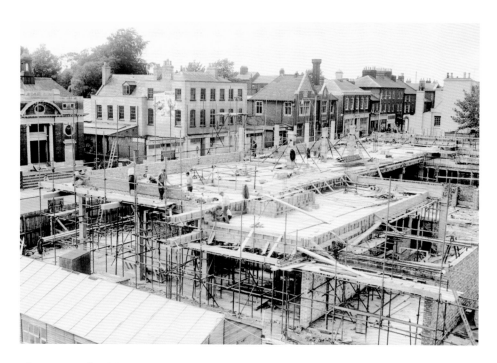

Thomas Burr's Old Home

The new shops being built on the corner of High Street North and Queensway in 1960 included Sainsbury's first supermarket in the town. In the background are some distinctive buildings that have now vanished. On the left is the old Palace Cinema, opened by cinema pioneer Fred Marchant in 1920, and next to it is the three-storey building known as the Manor House, which had once been the home of Thomas Burr. He owned a brewery nearby on land now occupied by Dunstable Community church.

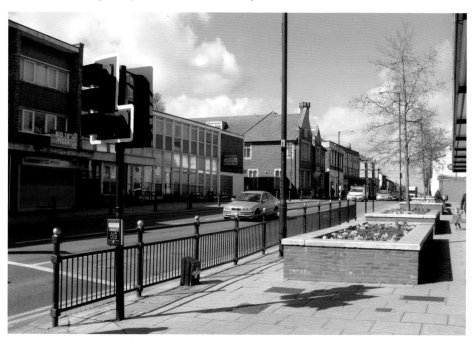

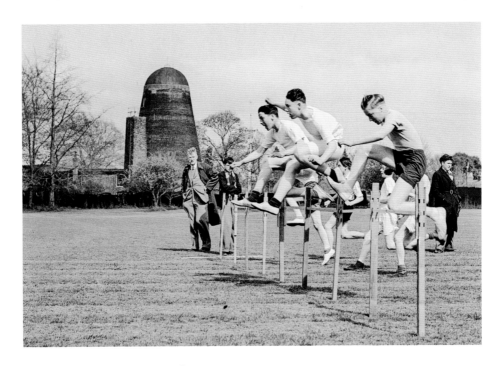

Windmill Survives for Sea Cadets

A hurdle race in progress in 1951 on Dunstable Grammar School's old playing field in West Parade. In the background is the tower of the windmill in West Street, which is now the headquarters of Dunstable Sea Cadets. A new Roman Catholic church, whose green spire can be seen in the colour photograph, was built near the windmill in 1964. Part of the new building for Ashton St Peter's Lower School can be seen on the right. The school moved there from Church Street in 2007 to make way for an Aldi supermarket.

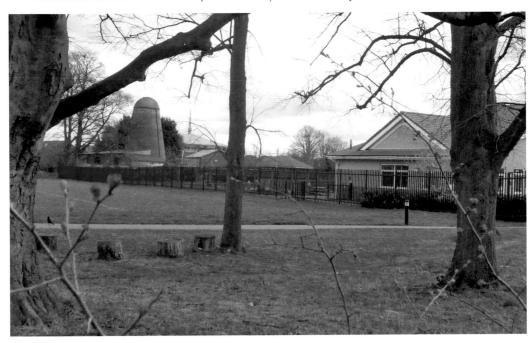

Car Park for the New Hall

Dunstable's town hall can be seen in the distance in this early view of the Civic Hall car park, with the rear of the new Queensway shops on the right. The Civic Hall, later renamed the Queensway Hall, opened in 1964 and the town hall, then deemed surplus to requirements, was demolished in 1966. The car parks for the new hall included spaces used for market stalls on Wednesdays and Saturdays. It is now all part of the Asda supermarket.

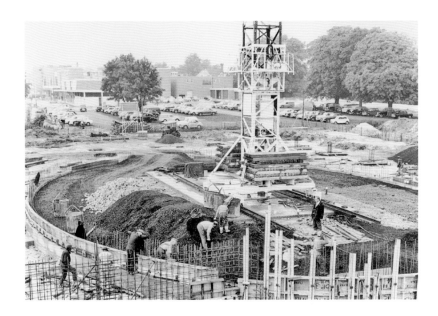

The Civic Hall Takes Shape

The familiar oval shape of the Civic Hall was just becoming apparent when this photograph was taken in 1963. The hall became a popular centre for exhibitions, banquets and balls. It was less successful as a venue for plays and musicals so the council, faced with huge structural repair bills, eventually sold the site to a supermarket chain. The proceeds were used to build the Grove Theatre nearby. Below is the scene in 2014, viewed from the opposite direction, with the Asda store on the hall site. The feature in the foreground is a representation of a Roman amphora.

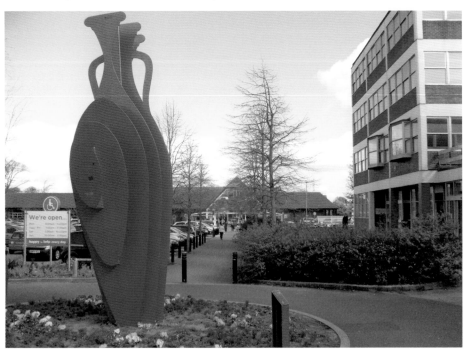

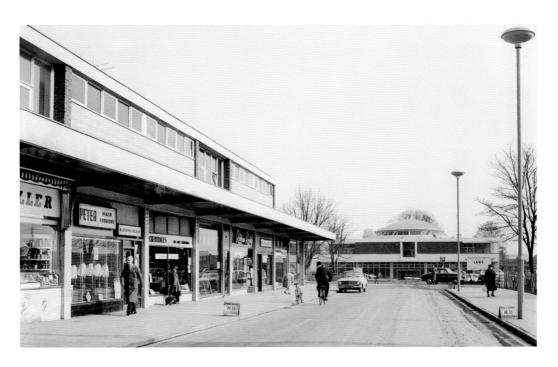

Looking Down Queensway

Brand new in 1964, the Civic Hall is seen where Asda is today, at the foot of Queensway, the new road built to provide access to a modern community area on what had once been Dunstable Park. Dunstable found itself with a swimming pool and leisure centre, magistrates' court, tenpin bowling centre, ambulance station and library, and to this was later added a theatre and a pub named in honour of Gary Cooper, the western film star. Cooper had played 'cowboys and indians' on the site when he lived in Dunstable as a pupil at the grammar school.

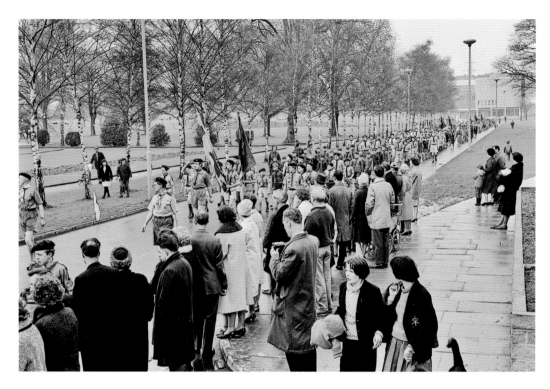

Before the Gary Cooper

Scouts marching along Court Drive, Dunstable, in 1964 were pictured by a photographer standing outside the Queensway Hall. Court Drive was then a fairly new road, giving access to Dunstable's new magistrates' court, hence the name. In the background are the trees and lawns of Grove House Gardens, where film star Gary Cooper played 'cowboys and indians' in his boyhood. The gardens subsequently became the site of numerous leisure facilities, including the swimming pool. The only recognisable landmark now is the college, seen in the distance.

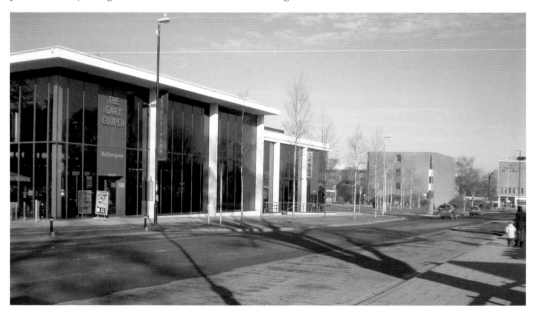

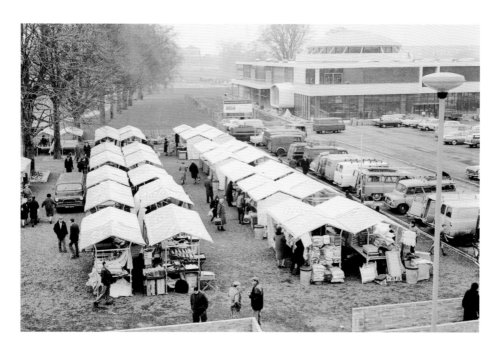

A New Site for the Market

Dunstable Market was traditionally held in High Street North, with the stalls erected on spaces alongside the road. The safety risks were obvious as the trunk road traffic increased, and when the Queensway Hall was built, the opportunity was seized to move the market to the new hall's car park. The stalls were moved once again to the present site near Wilkinson's, the theory being that trade would increase in the more central position. The colour photograph shows, in the distance, a bus travelling in Court Drive alongside the previous market site.

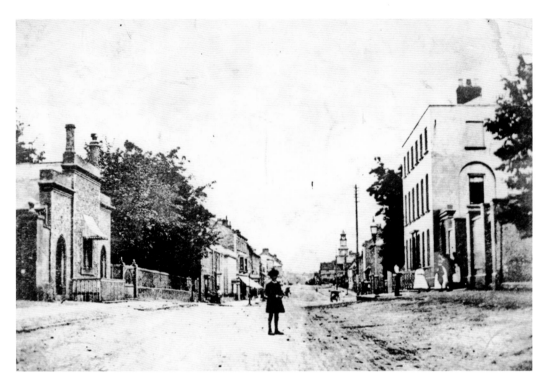

All Quiet in High Street North

A youngster stands in the middle of High Street North, with only a few horse-drawn carriages to worry about. The trees hide the front garden of the Victorian mansion known as The Lawn, with the Gothic building that became a doctor's surgery on the left. The so-called Manor House, once the magnificent home of brewery owner Thomas Burr, is on the right. The photograph dates from between 1869 and 1879, judging by what we know about the history of the town hall, seen in the distance.

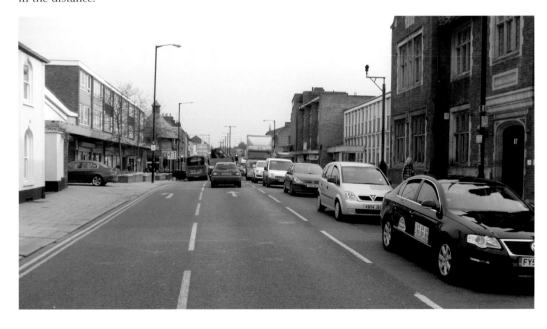

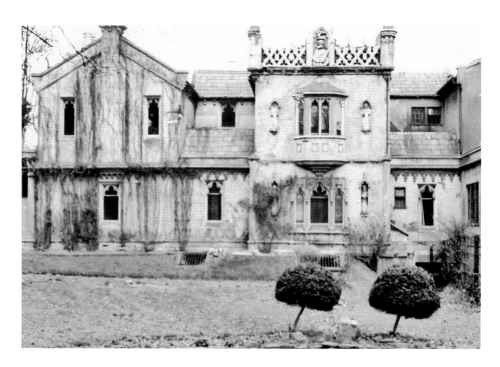

The Doctors' Vanished Mansion

The Lawn, which stood next to Grove House in High Street North, is one of the lost treasures of Dunstable. Its walls included a mural of the young Queen Victoria and a depiction of Chinese boat people using captive cormorants to catch fish. It had a large, tree-fringed lawn in front, which was covered with flowers in spring. For many decades, the house was the home of some well-known local doctors, including Dr Towland, Dr Binns and Dr Pinkerton. The site of their surgery, alongside the drive leading to the house, is now part of the Argos store.

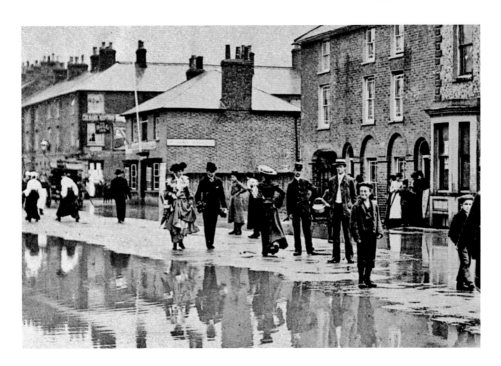

A Famous Coaching Inn

A name that provided a link to a famous part of Dunstable's past disappeared with the conversion into apartments of the old Bull Inn, on the corner of Union Street and High Street North. The building, now called Vale Court, is pictured here during flooding in the early 1900s. Behind it was a huge strip of land known as the Bull Closes, on which Henry Earle, owner of the country's first long-distance stage coach business, rested a large number of horses. By 1657, the Bull was one of the most famous coaching inns on Watling Street.

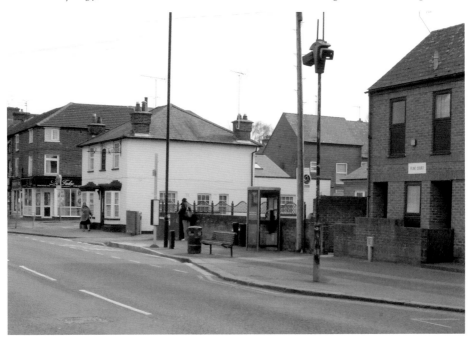

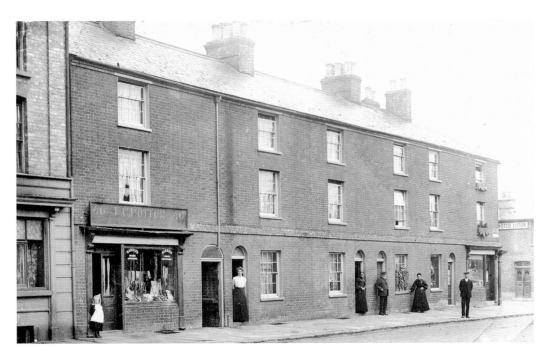

From Harness Making to Tattoos

How Dunstable shops have changed! The photograph above, taken around 1913, shows a shop opposite the old grammar school at High Street North, where E. C. Potton made harnesses for horses. Today, it's the home of Brent's tattoo studio. The little girl in the doorway is Phyllis Joyce Potton, daughter of the harness shop owner. Phyllis was born in 1906, which helped date the picture. Her grandson Chris Tombs, who lives in Culcheth, near Warrington, owns the photograph.

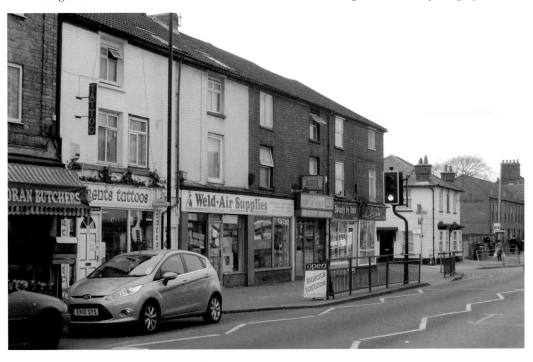

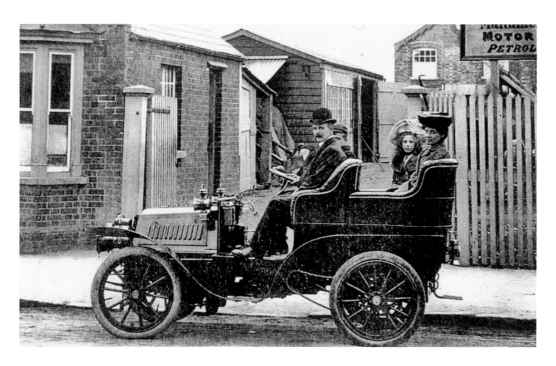

Dunstable's First Motor Car?

Bowler-hatted Alfred Jones, who ran the Albion Garage on the corner of Tavistock Street and High Street North, was pictured in the early 1900s sitting in his car outside the garage. The Tesco Express petrol station and supermarket now stand on the site. The best guess is that the vehicle is a French-built 1903 Panhard et Levassor. Alfred's niece, Mrs Betty Warren, who sent this photograph to the *Gazette*, was told that this was the first car to be owned in the town.

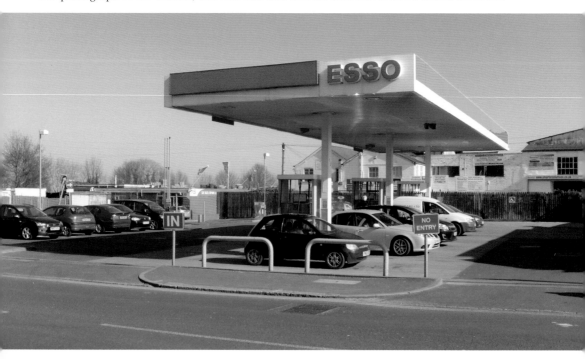

Why There's a Dip in the Road

A couple of workmen, armed with a pickaxe and shovel, were digging near the railway bridge in High Street North (and causing a bit of a traffic jam) when this photograph was taken in spring 1955. The bridge enabled trains from Luton to cross over the Watling Street to reach Dunstable North railway station and perhaps continue to Leighton Buzzard. As lorries (and buses) became taller, the road had to be lowered to enable traffic to squeeze under the bridge. Today, with the railway closed and the bridge demolished, just the dip in the road remains.

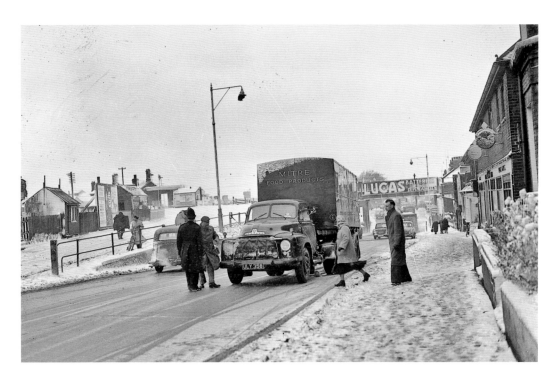

Slippery Slope Near the Station
This food lorry had problems climbing an icy slope in High Street North on a snowy morning in February 1958. The photograph shows, in the background, the entrance to the old Dunstable North railway station, the site of which is now occupied by the Central Bedfordshire council offices. The station opened in 1848 and closed in 1965.

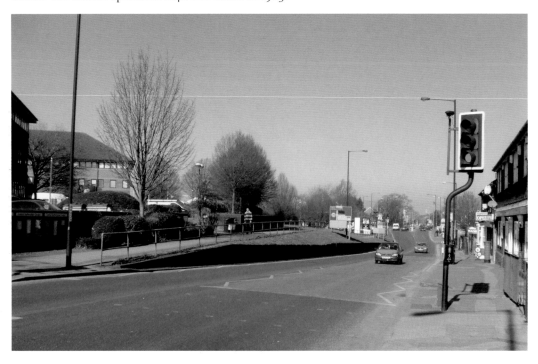

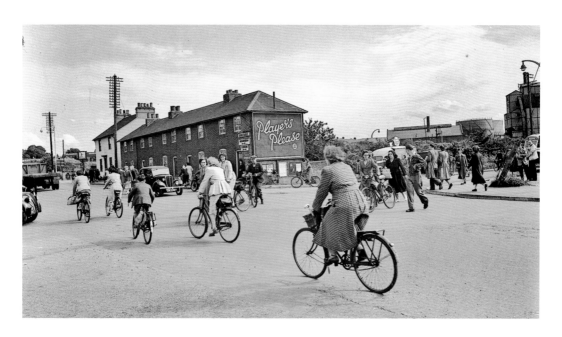

Delco Dash at Lunchtime

It's lunchtime, and workers at AC Sphinx have just enough time to cycle home for a meal before starting the afternoon shift. This photograph was taken in 1952 at the corner of Brewers Hill Road and High Street North. The Bird In Hand pub can be seen in the background. The cottages on the corner have since been pulled down and the site is now The Incuba, Central Bedfordshire College's business centre. AC Sphinx, the sparking plug manufacturer, was later called AC-Delco. The factory then became Trident and Trico before closing in 2003.

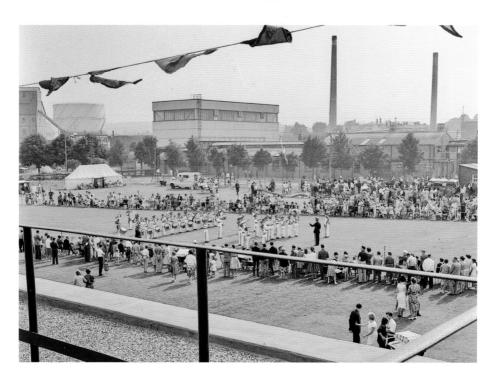

Homes Instead of Sparking Plugs

This corner of Dunstable, once the home of the huge AC-Delco factory, has been extensively redeveloped in the last few years. AC-Delco's sports field, on which a gala event was happening when this picture was taken in 1963 or 1964, is now almost completely covered by houses following the closure of the factory. The photographer would have been standing on the roof of the firm's canteen, with his back angled towards Watling Street. The colour photograph was taken in 2010 when the first houses were being built on the Delco site.

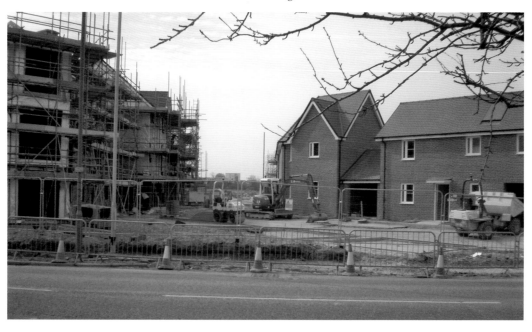

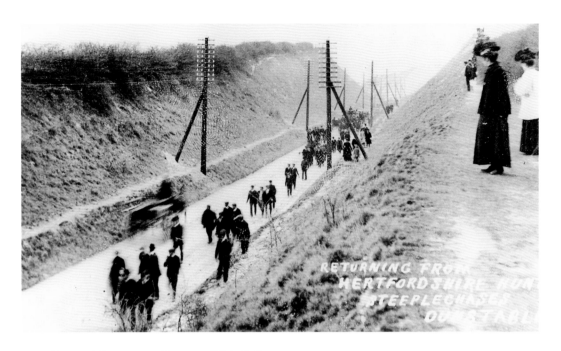

Doomed Attempt to Compete With Railways

Dunstable's chalk cutting was dug through the hill north of Dunstable in 1837 to make that section of the Watling Street easier for horse-drawn stagecoaches. It was a doomed effort to compete with the newly arrived railway and save the threatened stagecoach business, a big employer in Dunstable. Today, as the colour photograph shows, the remaining cliffs are overgrown with scrub. The older photograph, taken in Edwardian times and part of the Pat Lovering collection, shows crowds walking home from a steeplechase held by the Hertfordshire Hunt at Sewell.

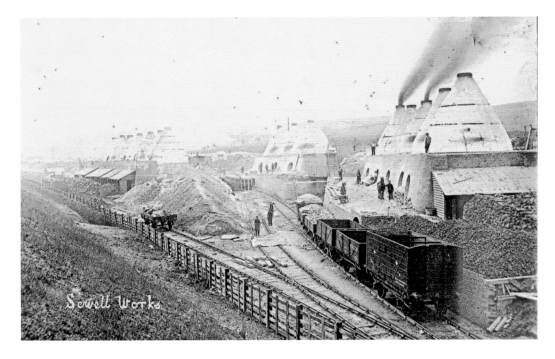

Scrub Now Hides the Old Kilns

Horses and railway trucks were all being kept busy when this photograph was taken of Sewell lime works. The works stood alongside Sewell chalk quarry, which can still be seen from the Green Lanes just outside Dunstable. The kilns were owned by the J. B. Forder lime company, which was operating at Sewell in the 1800s and sold the quarry to Blue Circle in 1912. Traces of the kilns are still visible in the colour photograph in what is now woodland, alongside what were once railway sidings. The main rail track has now been converted into a cycleway.

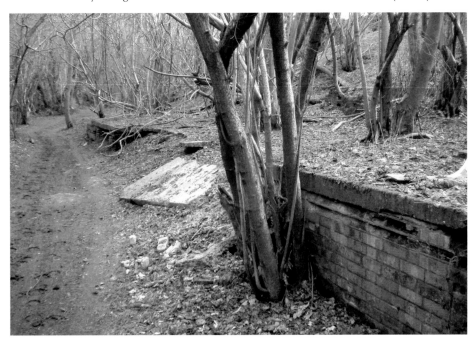

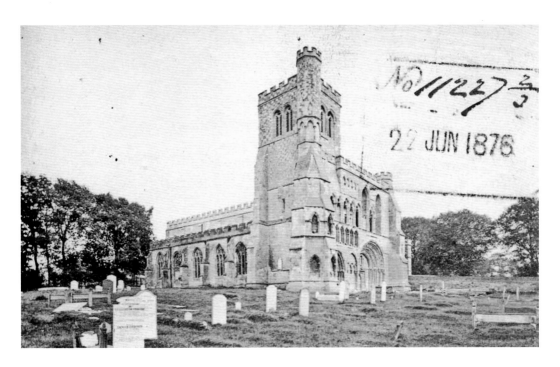

Date Stamp Provides the Evidence

An official at Lambeth Palace helpfully stamped the date on this picture, which makes it the earliest-known photograph of Dunstable's Priory church. It was sent by Mrs Fanny Collings of Collingwood House, Dunstable, to the Archbishop of Canterbury, along with a plea for money to help repair the church, which was in a dilapidated state in 1876. Priory church historian Hugh Garrod found the picture in the Palace library, and a digital version is now in the Dunstable Local History Society's research room at Priory House.

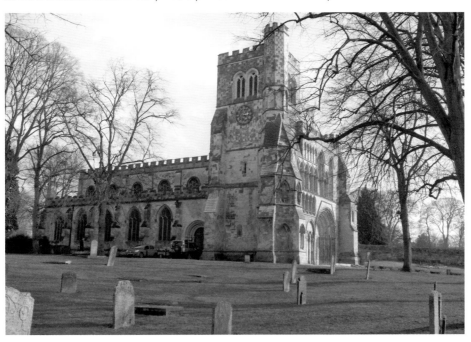

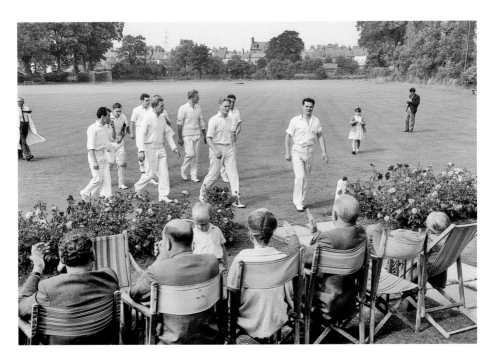

Where Cricketers Once Played

End of an innings at Dunstable Town Cricket Club's ground at Bull Pond Lane in 1957, and applause for the players as they return to the pavilion, which backed on to the lane. The sports ground opened in 1950 on two fields known as Great Woolpack and Little Woolpack, at the rear of the Woolpack public house in High Street South. The club moved to its present ground in Totternhoe in 1994 and houses were built on the Dunstable land, now named Woolpack Close. Seen in the distance in both photographs is The Poplars, built in 1887 and still the tallest building in High Street South. It is now the home of Regtransfers, the dealer in car number plates.

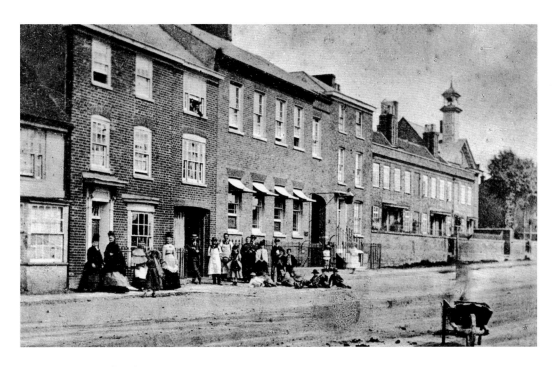

Many Uses for the Grey House

Workers outside a hat factory in High Street South in about 1870. Joan Curran, in her book *Straw Hats and Bonnets,* says historian Thomas Bagshawe found this famous photograph when he bought the building in 1923. For years it was known as the Grey House, but it was converted into a hotel in 1952. This in turn became the Downtown Café and then it was transformed into the Four Kings bar, which closed in 2013. Chew's schoolhouse is on the right.

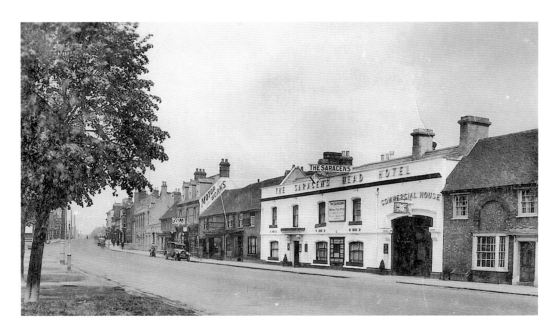

Where a Coin Hoard Was Discovered

The Saracen's Head in High Street South dates back to at least the sixteenth century, although most of today's building is newer – the result of a disastrous fire in 1815. The blaze revealed a hoard of gold and silver coins hidden under the floor of the pub's old stables. Most were minted during the reign of Charles I, although there were earlier coins dating back to Edward VI, so a reasonable assumption is that they were left there during the Civil War by someone who was never able to return. The garage and motor works owned by Councillor Ben Scott were replaced in the 1960s to accommodate the town's first Tesco supermarket. KFC and Cash Converters are on the site today.

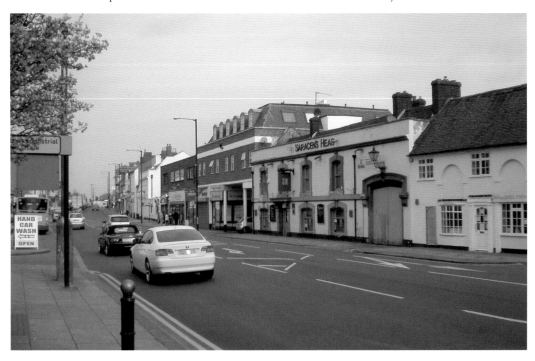

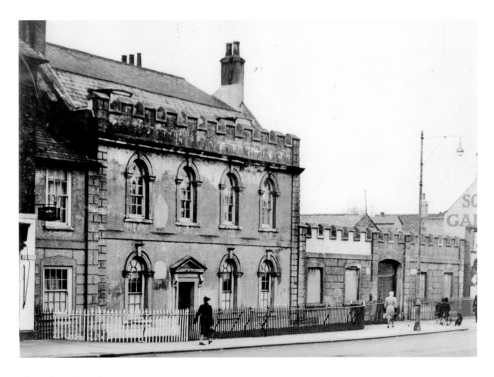

The Historic Priory House

Priory House in High Street South is one of Dunstable's most historic buildings. It may once have been a guest house run by the Priory monastery, or the home of one of the town's wealthy merchants. It is now owned by Dunstable Council and contains a tourist information centre, tea rooms, a heritage exhibition area and the local history society's research room.

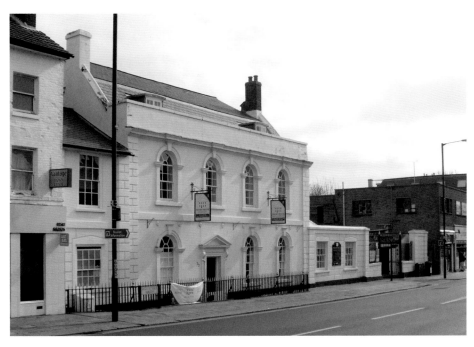

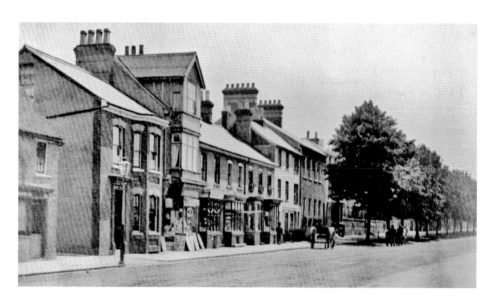

Clue From Russian War Posters

An unusual clue to the date of this photograph of High Street South, Dunstable, can be found in the booklet from which it was taken. It contained six views of Dunstable, which were perforated so they could be detached and used as postcards. It was produced on behalf of A. D. Sinfield, a tobacconist and stationer, whose shop at No. 27 High Street South can be seen in the tall building a few doors down from the entrance to Wood Lane. Newspaper posters shown in a drawing of the shop refer to the Russo-Japanese War, which raged in 1904/05. The booklet was loaned to the *Gazette* by Mrs Vera Griffiths of Stanbridge.

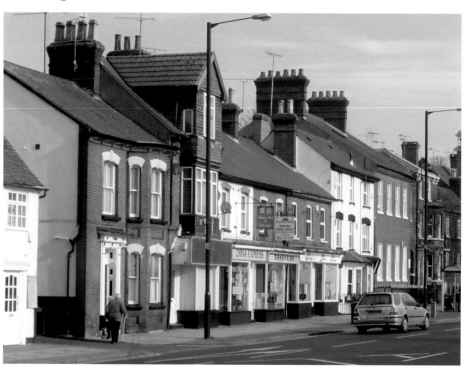

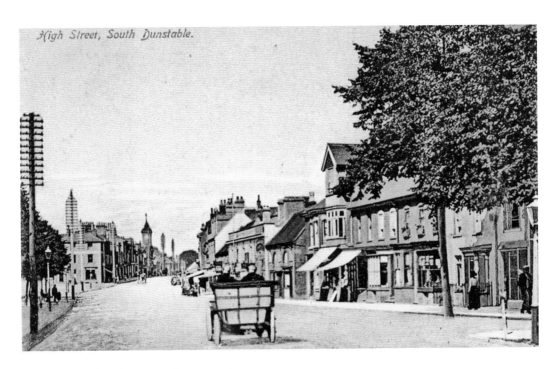

High Street, South Dunstable.

Telegraph Poles Have Disappeared

The car in the foreground of this postcard, which dates to around 1910, would certainly qualify for the London to Brighton run! But High Street South, Dunstable, has not changed too much over the years, apart from the volume of traffic and a host of street signs instead of the telegraph poles (which first appeared in Dunstable in 1863). Just past the entrance to Wood Lane is the distinctive frontage of the Saracen's Head, virtually unchanged apart from many more coats of paint. The Millennium Clock now stands on the Square. The postcard was provided by Christine Denn of London.

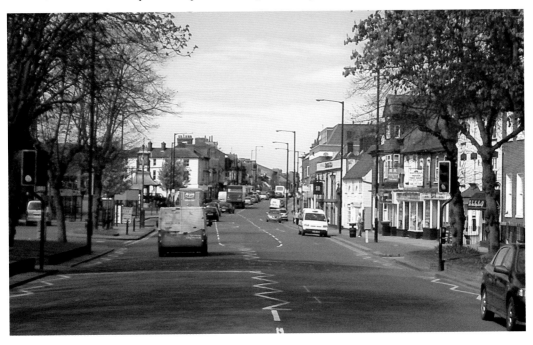

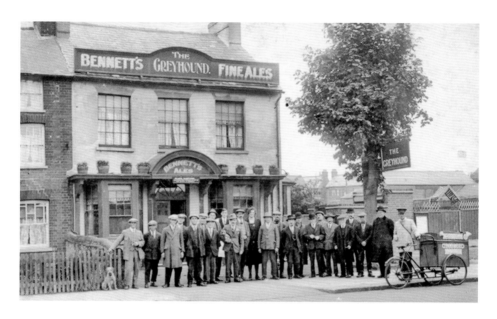

Ice Cream Man Outside the Greyhound

A travelling ice cream man, filling wafers and cornets from an icebox on front of his bicycle, was once a familiar sight. The vendor of Walls Ice Cream had stopped outside the Greyhound in High Street South, on the corner of Great Northern Road, when the photographer took this picture of a pub outing. The name of the pub licensee above the door appears to be Clara Bastiani, who was there in 1930. The Greyhound was owned by Benjamin Bennett's Dunstable brewery. His widow provided the funds for the Bennett Memorial Recreation Ground in Bull Pond Lane. The Greyhound today is a more modern building.

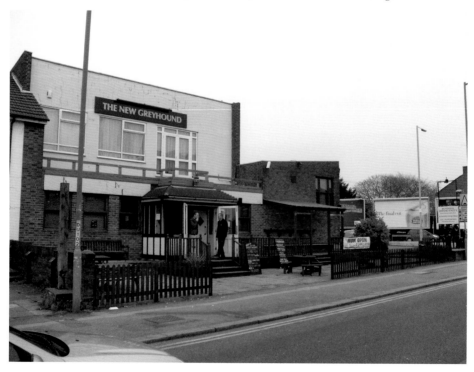

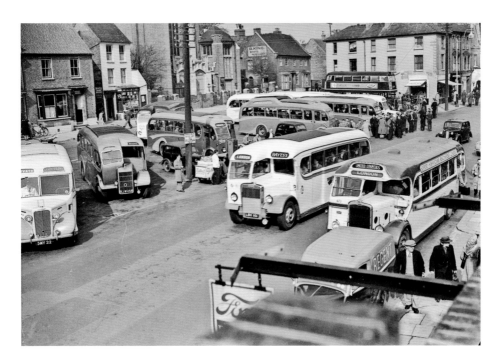

Bank Holiday Trips From the Square

Easter Saturday 1949, and the Square in Dunstable was the starting point for a host of holiday coach trips. The photograph, looking across High Street South towards the Methodist church, was taken from the upstairs window of the old Scott's garage that stood on the site of what is now Cash Converters and the KFC fast food outlet. Buses can no longer park on the Square, so today's photograph shows their new spot, with the Market Cross (erected to commemorate the Millennium) in the background.

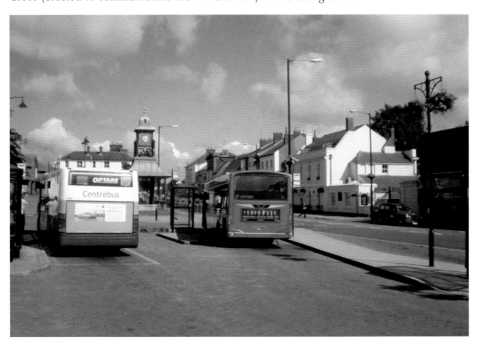

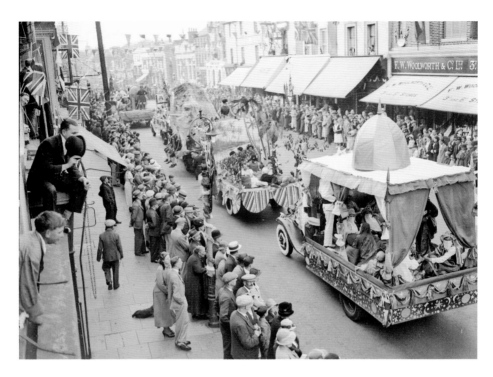

View from Middle Row

Crowds lined the High Street to watch the spectacular procession, which was one of the highlights of the town's Royal Jubilee celebrations in 1935. The *Gazette*'s photographer was leaning out of a window above the shops in Middle Row to take this picture as the floats reached the crossroads. Across the street, the shops included F. W. Woolworth's, which closed in 2009.

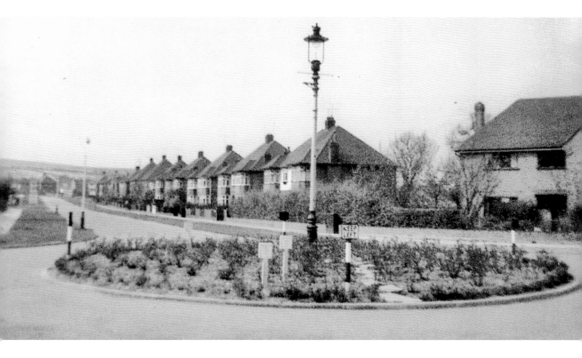

The First of Many Roads

What a difference some trees make! The picture shows First Avenue, Dunstable, in the early 1960s, with the houses clearly visible. Today, the trees and hedges have matured and hardly a building can be seen in the modern view. The original developer, Kingscroft Estate, had originally planned a series of additional roads over the adjoining fields to be called (unimaginatively) Second Avenue, Third Avenue, and so on. But planners in 1947 prevented the scheme from continuing, and it was not until the 1960s that Laing's opened up the area.

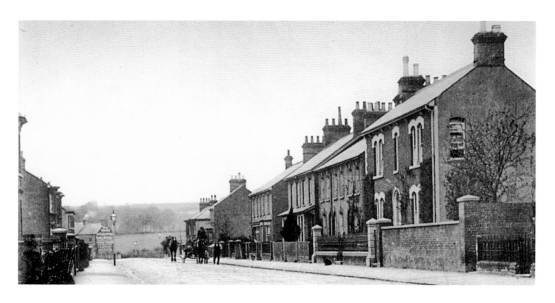

A Traffic-Free Great Northern Road

The horses may well be returning from a visit to the blacksmith's premises, which once stood just before the advertising wall on the far left of the picture. Traffic now overwhelms Great Northern Road, seen here looking towards High Street South. The old photograph was taken around 1910. The hills and trees in the background, from which you can still enjoy a countryside walk to Kensworth or Whipsnade, look similar today from this vantage point. But there is now a vast quarry over the brow of the hill.

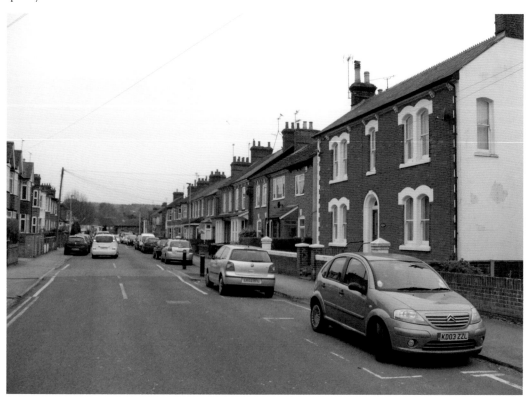

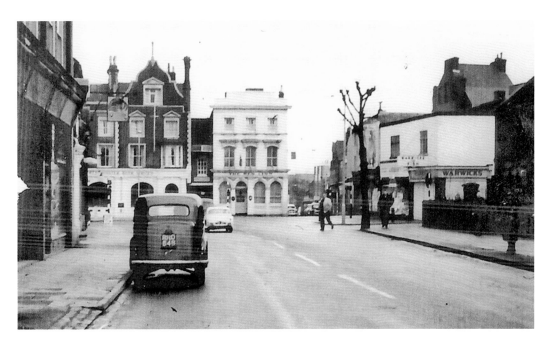

The Crossroads from West Street

There is no doubt about the year when this picture of Dunstable crossroads was taken. The photographer was Alf King, of Dunstable Road, Totternhoe, and he is sure it was 1964 because that's his Ford Anglia in the foreground, parked outside the old Co-op grocery shop (part of which is now a pharmacy) in West Street. This view not only shows the Red Lion hotel, which stood on the corner of Church Street before the road was widened, but also the old Westminster Bank, which was knocked down and replaced by the present flat-roofed NatWest building.

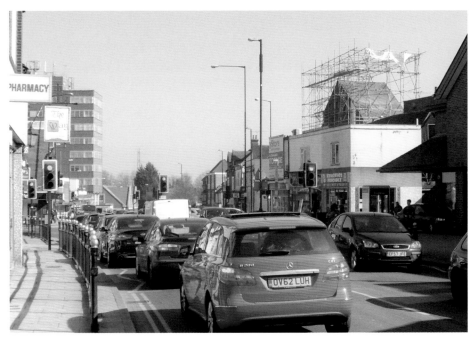

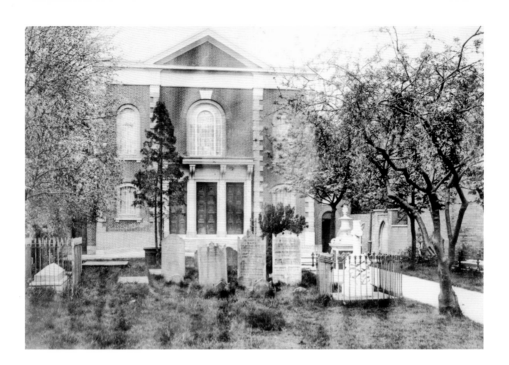

Christ Church in the 1900s

The Baptist Chapel in West Street, photographed around 1900. The gravestones were moved around 1945/46 during the ministry of the Revd Leslie McCaw. Dunstable Baptists originally met in a tiny building at Thorn, near Houghton Regis, but erected a small meeting house in Dunstable in 1801 on a piece of land in West Street given to them by Mr R. Gutteridge. They put up the present building, now called Christ Church, in 1847.

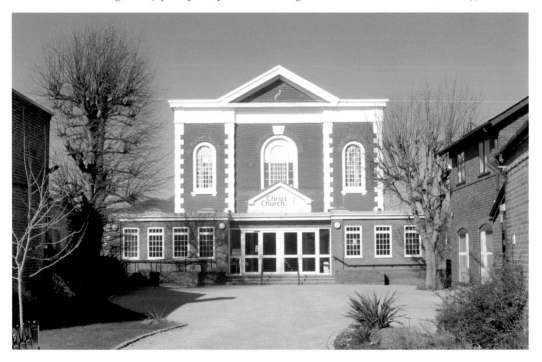

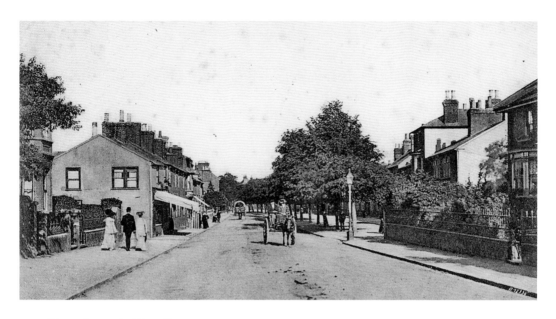

Horse Power in West Street

A couple of horse-drawn vehicles make their gentle way along West Street in this postcard from Edwardian times. The photographer was looking towards the town centre, with the entrance to Icknield Street visible on the right. He would have been standing in the centre of the road – a position difficult to achieve in today's traffic. The shop on the left, on the corner of Princes Street, is still readily recognisable. It has recently become the home of a branch of Boots. The postcard is from a collection belonging to Maurice Matthews.

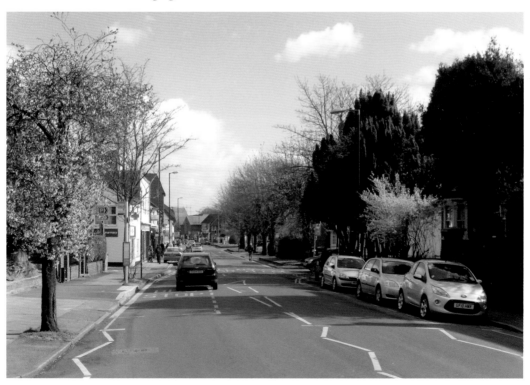

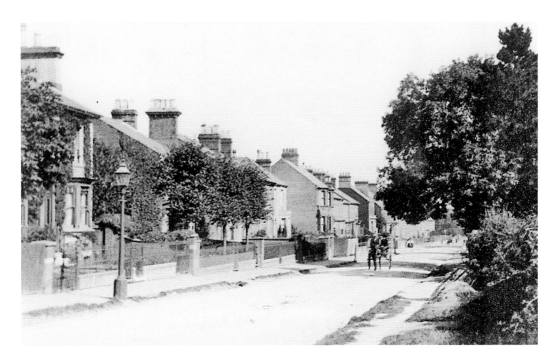

Alongside the Cemetery

A horse and cart travel along what we would today consider to be the wrong side of the road in this early photograph of West Street, Dunstable, looking in the direction of the crossroads. It was taken in Edwardian times, alongside what is today the new extension to Dunstable cemetery. Many of the houses on the left have been extended or otherwise altered, but it is still readily recognisable. The trees on the right-hand side, then and now, are on the edge of the large property that was once the home of the Gutteridge family.

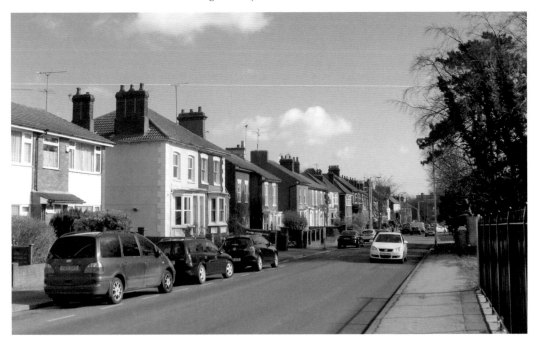

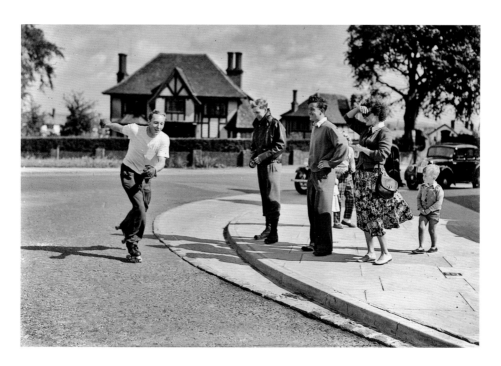

Beechwood House in the Background

Roller-skater Dennis Lindsell rounds the corner of Whipsnade Road from West Street, Dunstable, in August 1957, while taking part in a London to Dunstable roller-race, starting from the Houses of Parliament and ending at the roller-skating rink at the California swimming pool. The large building in the background of the photograph is Beechwood House, home of Mr A. F. England. The Beechwood Court flats now stand on the site. Behind Beechwood House was a field that contained the pylons and headquarters of the Meteorological Office.

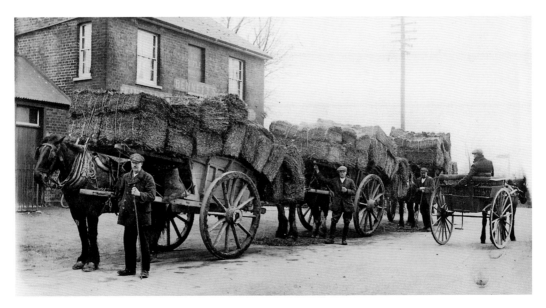

Outside the Rifle Volunteer

Ever wondered how the thousands of horses that drew London's cabs and carriages in pre-automobile days were fed? This photograph, taken in Dunstable in 1914 or early 1915, provides the answer. Local farmers supplied bales of hay, which were collected regularly and transported to the city by train. These loaded carts have come from the Whipsnade area and are seen outside the Rifle Volunteer pub, on the corner of West Street and Whipsnade Road. The photograph belongs to Trevor Turvey, whose dad, Jim, is in the centre of the picture. The smaller photograph shows the demolition in 1969 of a later pub on the same site.

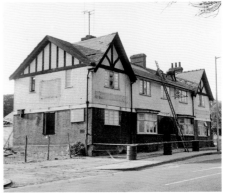

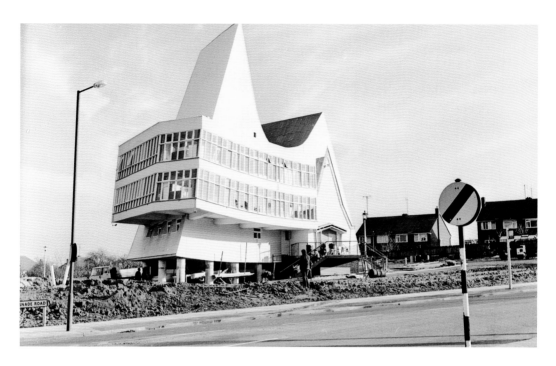

Short Life of the Windsock

The Windsock was an ultra-modern pub and restaurant, which was built on the site of the old Rifle Volunteer pub on the corner of Whipsnade Road and West Street. It was an attractive venue, with a copper-clad roof that was meant to weather eventually into a greenish hue and thus blend in with the nearby downs. But the building was beset by structural problems and closed after only a few years, to be replaced by housing.

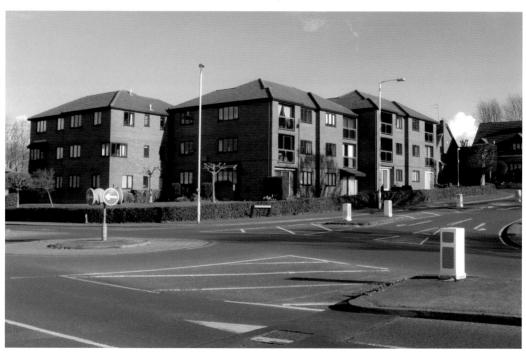

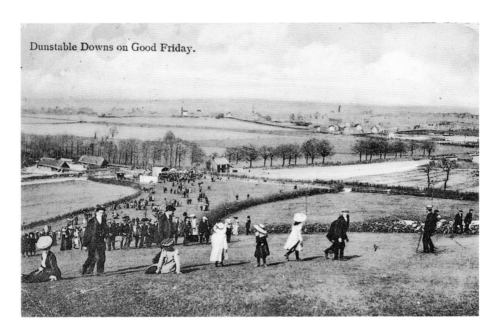

Dunstable Downs on Good Friday.

Good Friday Fun on the Downs

Good Friday used to be celebrated in unique style in Dunstable. This was the time when the annual orange rolling event took place on the steep slopes of Pascombe Pit on Dunstable Downs and the picture shows crowds making their way up the hill from Tring Road. It was once a day of huge fun, with fairground attractions, bands and, of course, orange vendors. The low-slung buildings on the left are the old Rollings whiting works and the solitary building in the centre of the photograph is the Rifle Volunteer pub. This photograph, with the houses of Dunstable still far in the distance, is from a postcard, perhaps posted in 1913, owned by David Underwood of Totternhoe.

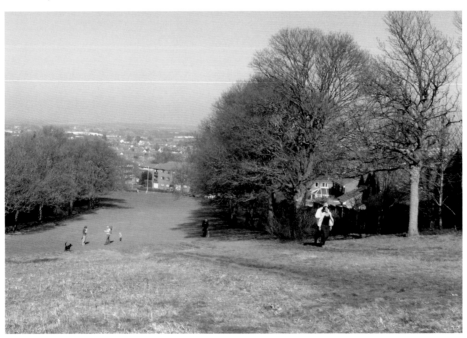

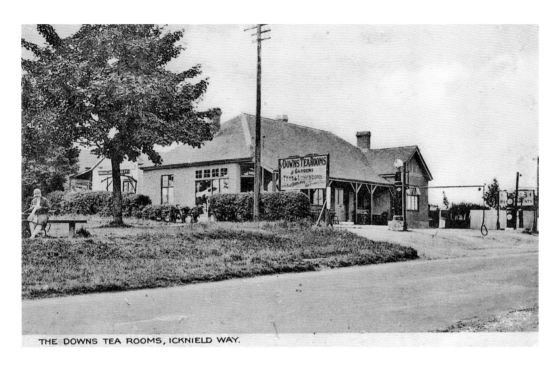

THE DOWNS TEA ROOMS, ICKNIELD WAY.

Tea Rooms Were So Popular

The Downs Tea Rooms at the foot of Dunstable Downs, near the West Street/Whipsnade Road corner, were once so popular that they became the subject of this souvenir postcard. It was posted in October 1941, but the card must have been published some years earlier. A petrol station is still next door, although today it is very much a self service operation. The old photograph was taken in the times when drivers could ask a pump attendant to 'fill her up, please' and pay him without ever leaving the car. The card was sent to the *Gazette* by Mrs June Martin of Grove Road, Dunstable.

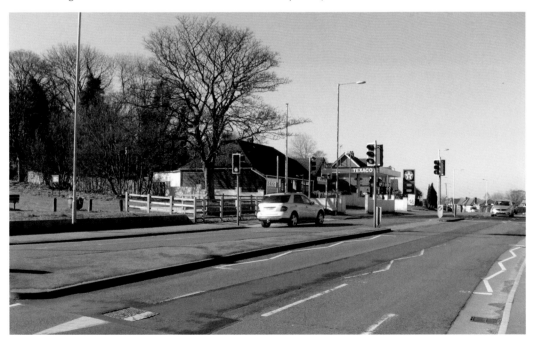

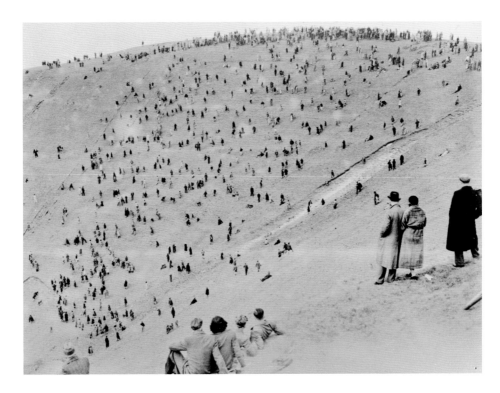

Orange Rolling at Pascombe Pit

The ceremony of rolling oranges down Pascombe Pit used to attract enormous crowds for the annual Good Friday scramble for free fruit. The tradition was abandoned amid worries that someone would be injured on what is a very steep slope, as demonstrated by the colour photograph taken in spring 2014. The *Gazette* in 1899 recorded in great detail the fantastic free-for-all when anything within the law was allowed and one trader livened up the day even more by providing 'Lady Teasers', which, apparently, were rubber missiles filled with water.

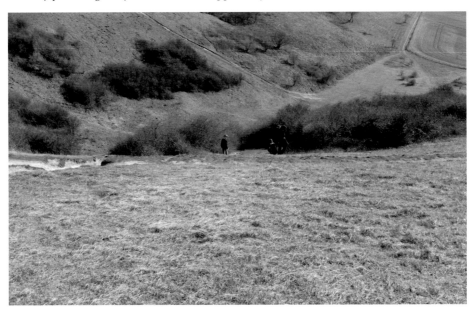

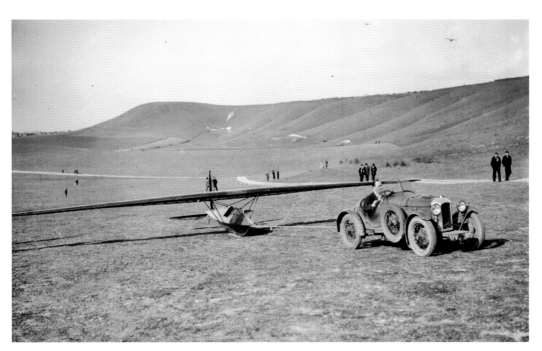

Pioneer Gliding on the Downs
The London Gliding Club, formed in 1929, began launching from the top of Dunstable Downs after earlier flights from Ivinghoe Beacon. The photograph above, taken in 1935, shows a car towing a glider back to the downs for another aerial attempt. This was the year when the club replaced its wooden hangars at the foot of the downs with a splendid modernist building. The remarkable colour photograph, featuring both a vintage and a modern glider soaring above the old visitors' centre (now replaced) was taken in 1990 by Tony Hutchings (www.tonyhutchings.co.uk) using a radio remote-control camera mounted on a wing tip.

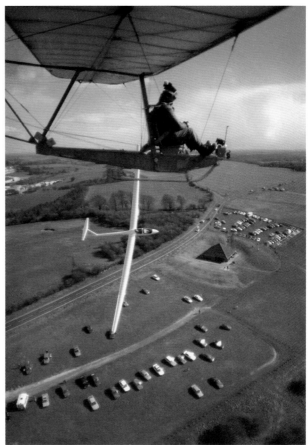

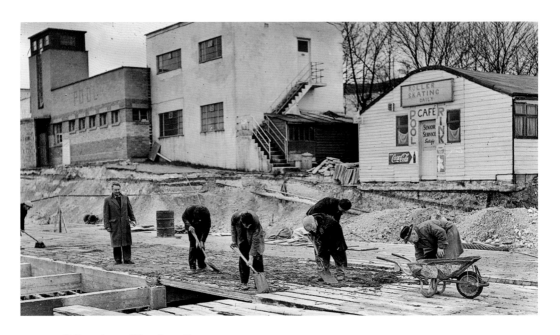

Building the California Ballroom

Edwin Green was not content with running and owning the beautiful California Swimming Pool, an open-air venue where sunbathers could relax in an idyllic (but sometimes chilly) setting on the grassy slopes of the downs. He expanded the premises to accommodate a roller-skating rink, whose café is seen in the background of this photograph taken in February 1958. The picture records the moment when Mr Green began a new and exciting enterprise, building an enormous ballroom on the swimming pool's forecourt – a venue which was to host a series of stars, including the Rolling Stones. The swimming pool closed in 1973 and the ballroom was demolished in 1980. Royce Close is there now.

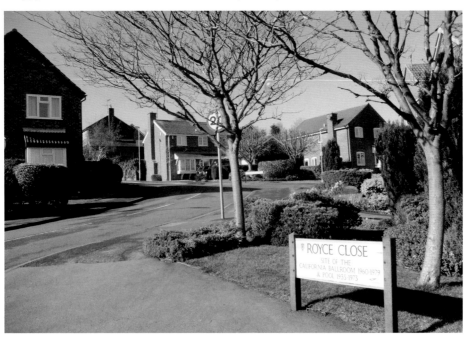

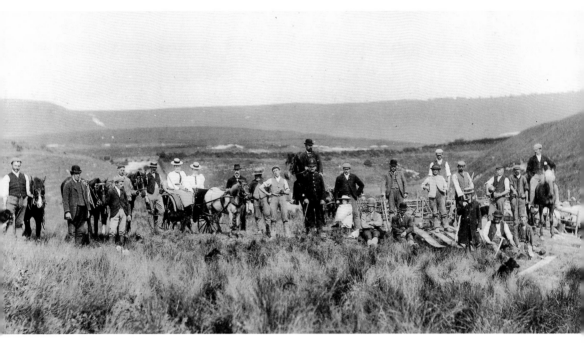

Jugs of Beer at Sheep Dip Time

For many centuries, the slopes around Dunstable Downs provided grazing for thousands of sheep. This photograph appears to have been taken some time before 1904 near the source of the stream at Wellhead alongside Tring Road. Some of the shepherds (for whom refreshments in stone beer jugs seem to have been available) are carrying long poles, so the occasion is clearly a round-up of flocks for dipping. The poles were used to push the animals under the water and thoroughly wash them before they were clipped for wool.

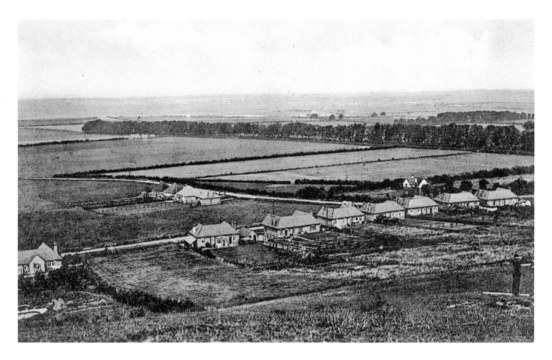

First Bungalows in Tring Road

The bungalows in Tring Road, at the foot of Dunstable Downs, had just been built when this photograph was taken, probably in the early 1930s. The photographer was standing on the hill overlooking west Dunstable. The bungalow on the left seems to be the one opposite what is now the entrance to The Avenue, and Totternhoe Road stretches across the fields in the distance. Only two or three houses had been erected in Totternhoe Road at the time and there's just one building on the other corner, approximately where Oakwell Close is now situated.

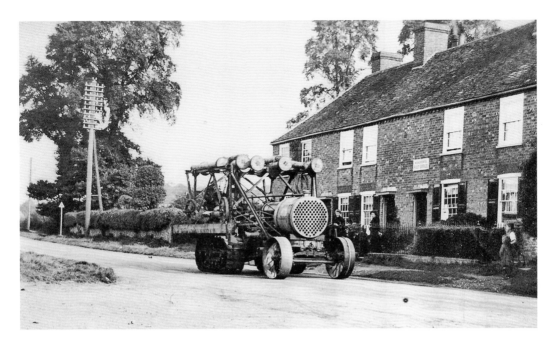

Pioneer Tank at the Packhorse

This extraordinary vehicle was photographed travelling down Watling Street, passing the old Kensworth post office, which, until the early 1930s, was in a cottage opposite the Packhorse pub. Steam model engineer Steve Elliott was able to identify the vehicle. It is a Bullock Creeping Grip California Giant, two examples of which were used for evaluation during the development of the tank in the early part of the First World War. Whether this particular machine was part of that programme is not known. The huge vehicles, made in Chicago, Illinois, had been shipped across the Atlantic from the USA and tested at Burton upon Trent in June 1915.

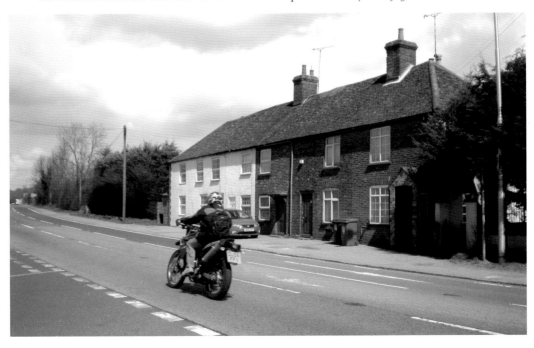

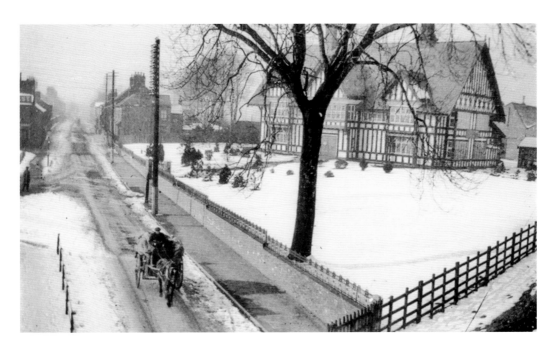

Exhibition Origin for Bagshawe's Office

The distinctive offices in front of the Bagshawe engineering factory in Church Street were originally built for the White City Exhibition at Hammersmith, and then used as the 'Fauna Pavilion' in the Festival of Empire Exhibition at the Crystal Palace. Bagshawe, whose factory opened in Dunstable in 1908, bought the pavilion in 1913. The snowy picture shows a horse and cart about to reach the old railway bridge. The factory, specialising in conveyor installations, closed in 1972 and its landmark frontage burned down in 1978. The site became the Dukeminster industrial estate and, from 1981, offices for ABC Travel Guides.

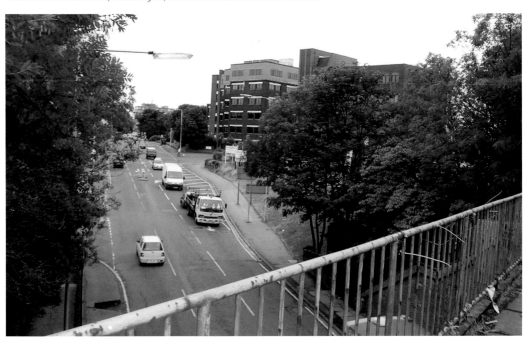

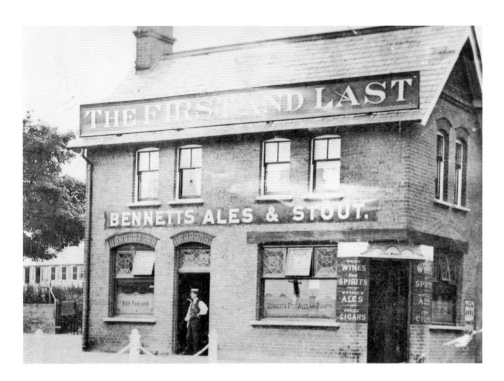

Old People's Apartments Arrive

Further transformation of the corner of Church Street by the old railway bridge is underway at the time of writing. The span of the bridge has been replaced by a structure more suitable for the new busway and the 1981 offices have been demolished. Old people's apartments and facilities, to be called Priory Heights, are currently being built. Across the road, the First and Last pub is established as a Meet and Eat venue. The sepia photograph shows the pub around 1906 before it was rebuilt.

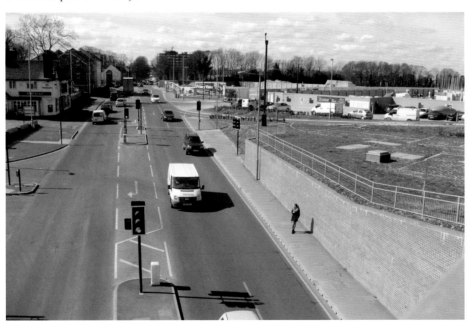

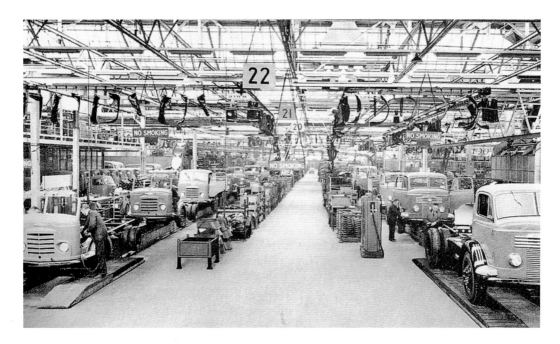

Inside the Commer Truck Factory

The changing face and fortune of Dunstable is graphically illustrated here. The older photograph shows the twin assembly lines of the Commer vehicle plant in Boscombe Road, Dunstable, making Bantam and QX trucks. Production began there in 1955. The colour photograph shows work continuing in April 2014 to build retail warehouses on the cleared site. At one time, Boscombe Road was an enormous centre of employment, with thousands working at Commer's and in the huge Bedford truck factory on the other side of the road. However, the worldwide truck market dwindled and vehicle assembly on the Commer site stopped in 1993.

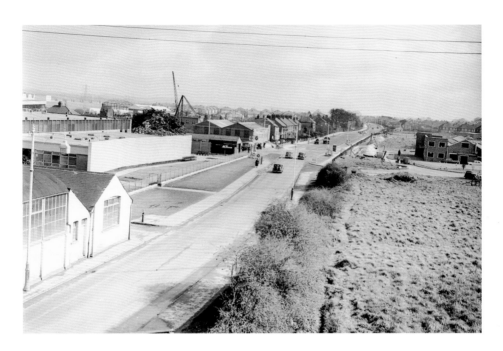

Luton Road View From the Bridge

Remarkably little traffic can be seen in Luton Road when viewed from the old railway bridge in March 1957. The building on the left was once a hat-renovating company. It then became a builder's merchants and later a dairy, standing next to Vauxhall Motors' Bedford Truck factory. The crane was a familiar landmark for many years, working in the Frederick Carter scrap metal yard. The yard became a tile retail centre for a time and in 2014 was developed as the Market Cross restaurant. The Vauxhall site is now occupied, in part, by a Sainsbury's store. Wickes builders' merchant is now on the land on the right.

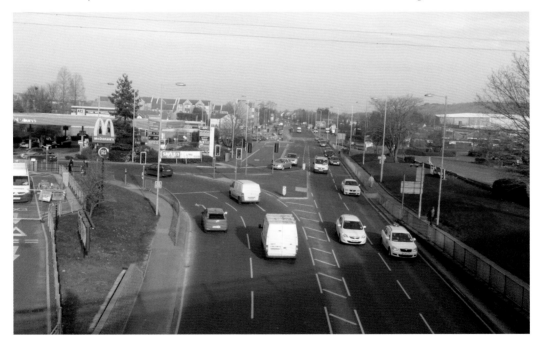

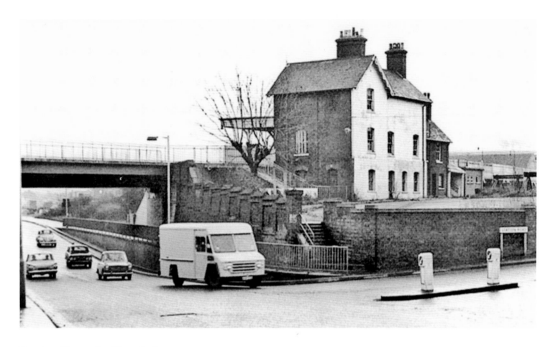

Station House in Church Street

The new busway between Dunstable and Luton has transformed the old branch railway, which had been disused for many years. This photograph shows the old bridge and station house in Church Street. It was probably taken just before the passenger service ceased in 1965. The station had opened in 1858 but most of it was destroyed by a fire in 1870 and had to be rebuilt. There were two railway stations in Dunstable. The other, Dunstable North, stood on the site of the present Central Bedfordshire Council offices.

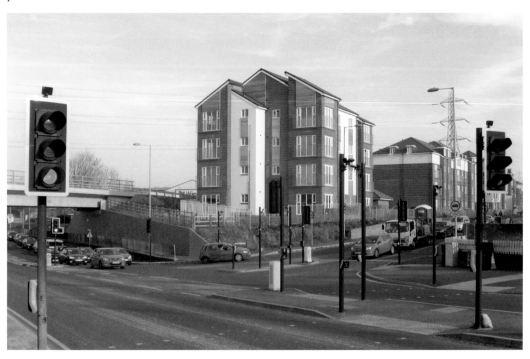

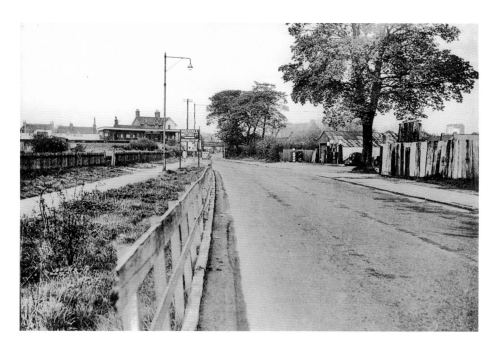

Turn Right for Vauxhall

That's what the sign says, in a photograph taken when the route to the Dunstable factory, built in 1942, was not too familiar. The photographer was looking down Luton Road, towards the railway bridge. The petrol pumps on the corner of Boscombe Road were on the forecourt of a car repair business owned by Bill Liberty. The site is now the home of the ATS tyre and exhaust garage. The fence on the right hid the Frederick Carter scrapyard, where the Market Cross restaurant now stands. The car about to be driven under the bridge is a Jowett Javelin, which was produced between 1947 and 1953.

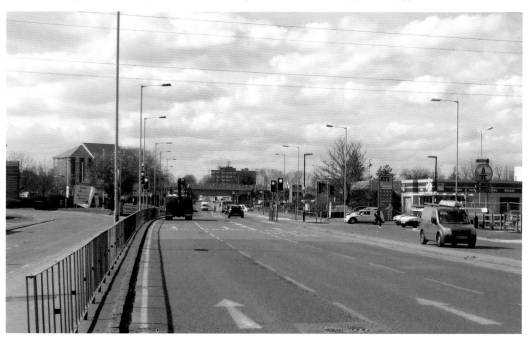

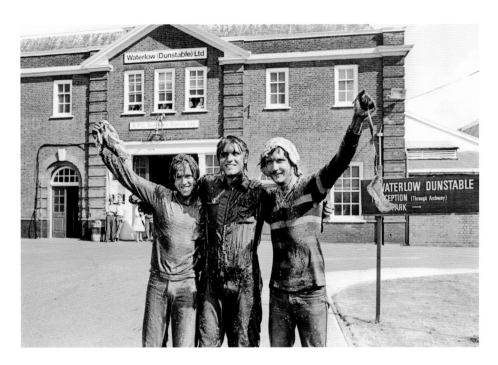

Banging Out at Waterlow's Printworks

The centuries-old craft of printing was a highly skilled job and when apprentices passed their final exams, it was an occasion for a boisterous celebration called 'banging out', which involved being doused with liberal amounts of printing ink and other antisocial materials. These lads (that's Barry White on the left) were pictured in 1981, after happily undergoing the ordeal. They are seen in George Street, Dunstable, outside the entrance to Waterlow's, once a giant printing factory employing 1,700 people. The factory was demolished in 1995.

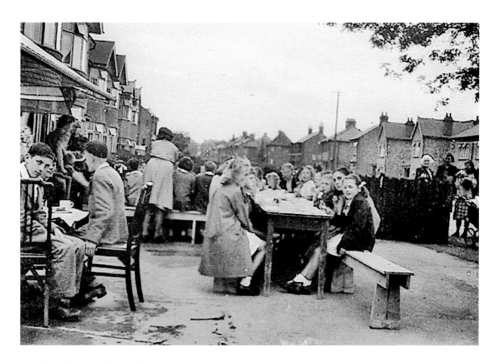

Celebrating War's End at Douglas Crescent

There were numerous street parties all over Great Britain in 1945 to celebrate the end of the Second World War. This photograph, from the Pat Lovering collection, shows the children's party held at the bottom of Douglas Crescent, on the Houghton Regis/Dunstable border. That's Northfields in the background. The tables were on the forecourt of the grocery shop which once stood on the corner. It is now a private house. Douglas Crescent was built by the local developers Mead Estates and named after Douglas, the youngest son of Walter Mead.

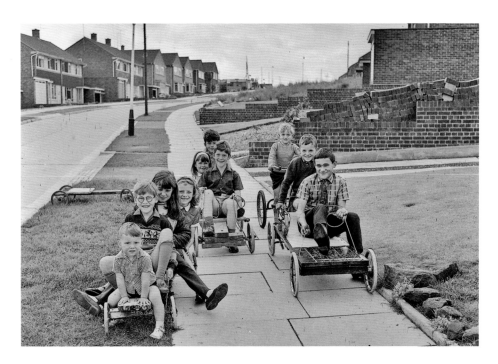

Karting Fun at Appleby Gardens

There's a long slope down Appleby Gardens, Dunstable, which made it ideal for home-made karts, and these children had hours of fun on vehicles assembled from planks of wood and old pram wheels. Mind you, the road was very quiet when this picture was taken in the early 1960s. Appleby Gardens is part of the housing estate created on the southern slopes of Dunstable Downs by Laing Homes, whose building depot with the flat roof is at the top of the road. Laing's sold its depot land in 1969 to allow for the creation of what is now the Langdale church.

Looking Down Chiltern Road

Chiltern Road, Dunstable, has hardly changed at all since this photograph was taken, probably around 1920. Even the fir trees on the left remain – or, at least, new ones have been planted. The photographer was looking in the direction of High Street North. Just around the corner on the right would have been Chiltern Road School, which became the studio for Chiltern Radio in October 1981 and then Heart FM. The lady walking down the road is very close to the turning into Cross Street North, which 'crosses' from Chiltern Road to Beale Street.

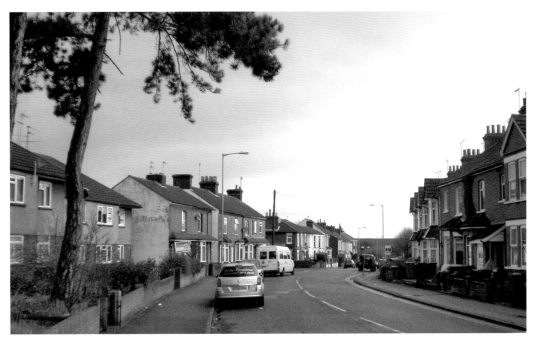

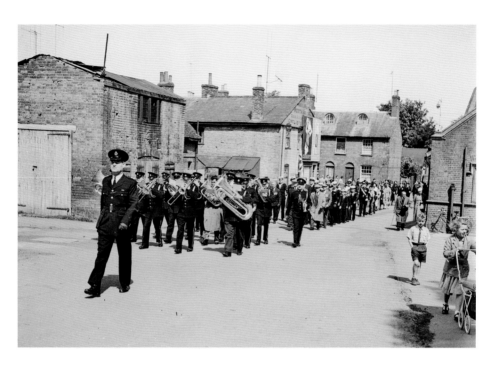

Silver Band in Church Close

Dunstable's Excelsior Silver Prize Band, a fixture in the town's life between around 1865 and 1960, is seen leading a procession into Church Close in the 1950s, with one of the borough's senior policemen, Inspector Bill John, spearheading the parade. They are marching towards the Priory church through what is now a car park, with Church Street in the background and the parish hall, formerly a church school, on the right. The school was built in 1838 on land where a weekly plait market had previously been held.

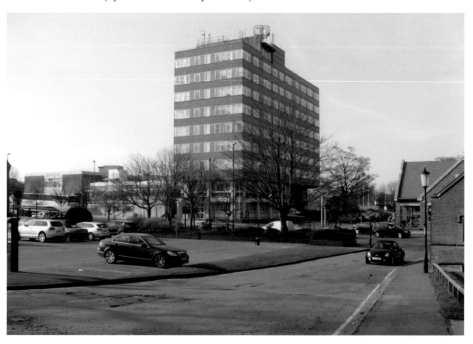

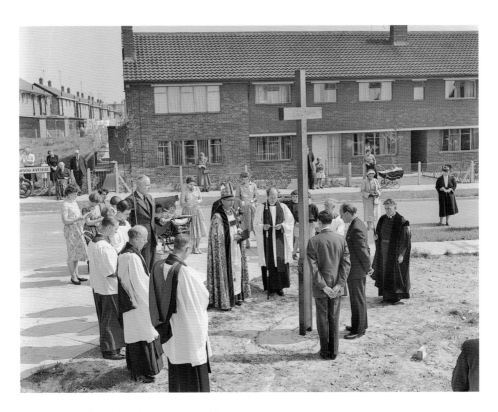

St Augustine's Dedication at Downside

A day of ecclesiastical pageantry on the Downside estate in May 1959 when the Bishop of Bedford, the Rt Revd B. T. Guy, held a consecration service to hallow land in Oakwood Avenue on which St Augustine's church was being built. The congregation at the service was seated (behind the photographer) on chairs placed on the recently laid floor of the building, a flat-roofed structure that was replaced by the present church (*inset*) in 1992. The bishop was accompanied by the Archdeacon of Bedford, the Ven. B. C. Snell.

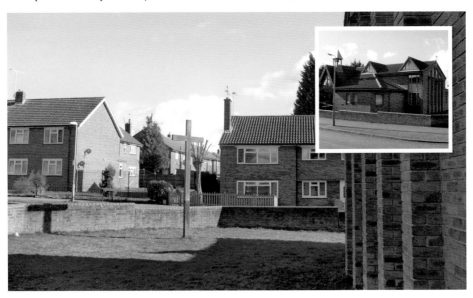

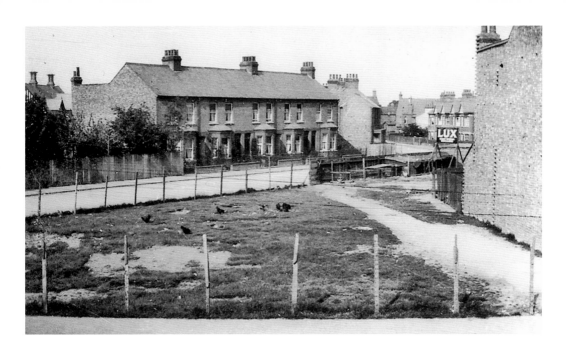

Eggs for Breakfast in Alfred Street

Chickens were living happily on a piece of open ground, once known locally as The Green, on the corner of Alfred Street and St Peter's Road, Dunstable, when this old photograph was taken. The open land is still there today, covered with grass, trees and road signs, but definitely no chickens. Frank Eyre, who was stationmaster at the Church Street railway station nearby, probably took the snapshot during the First World War. The location has been identified thanks to the Tudor-style building just visible in the background, which is clearly the Bagshawe engineering factory in Church Street.

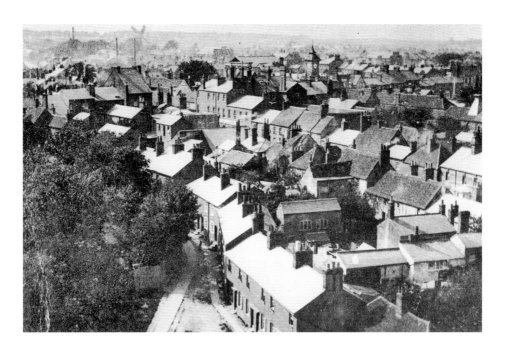

From the Priory Church Tower

A view of Dunstable town centre taken from the top of the tower at the Priory church, probably in 1904. The houses in the foreground stand on what is now the church car park. Most of the properties near the right of the photograph were demolished to allow Church Street to be widened and the Quadrant shopping centre to be built. In the distance can be seen the sails of the windmill in West Street, which is now the headquarters of Dunstable Sea Cadets. Its sails were removed in 1908, which helps to date the photograph, from the collection of Dunstable & District Local History Society.

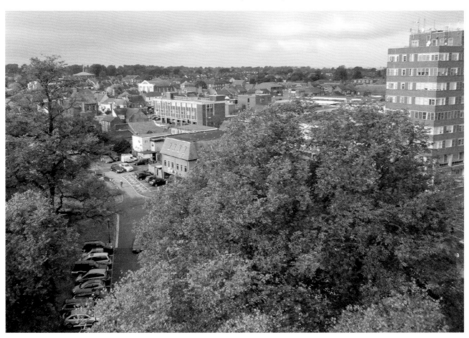

Wartime Vigil at the Empire Rubber Co.

It was a lonely job for this man during the Second World War. He was watching out for war planes from the roof of the Empire Rubber Company's factory in London Road and had an air-raid siren ready for use. The photograph was taken in 1941, three years after the firm built its huge premises in Dunstable. In the background are Blow's Downs and the fields that later became the Downside estate. The factory closed in 2002 and the Eleanor Gardens houses are being built at the time of writing alongside a new Holiday Inn. The picture was loaned by Michael Bonnar, who was the firm's senior advanced quality planning engineer.

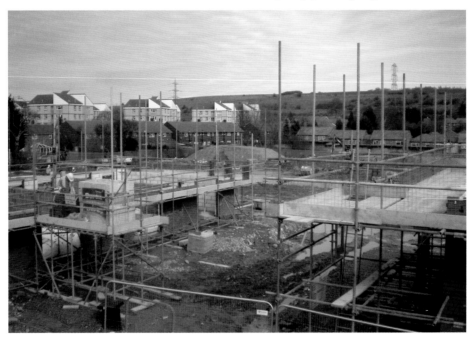

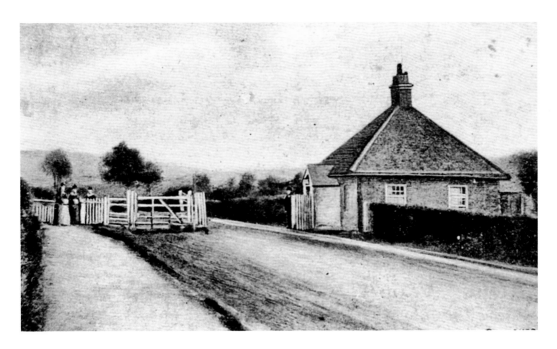

The Toll Gate on Half Moon Hill

Toll gates stood on various parts of the Watling Street around Dunstable. The one in the picture was at the top of Half Moon Hill, and the artist would have been looking south, in the direction of Kensworth. The hills seen faintly in the background are Blow's Downs. Some new flats, opposite the entrance to Oldhill, have been named Tollgate Court to commemorate this piece of Dunstable's history. The toll gate house in the picture would have been on the other side of the road, nearer the Half Moon pub. The toll gate charges were very unpopular and it was closed amid local jubilation on 31 October 1877.

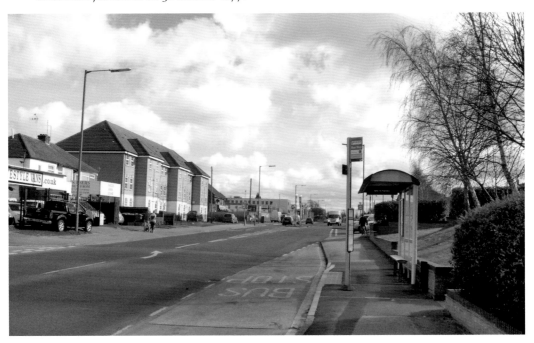

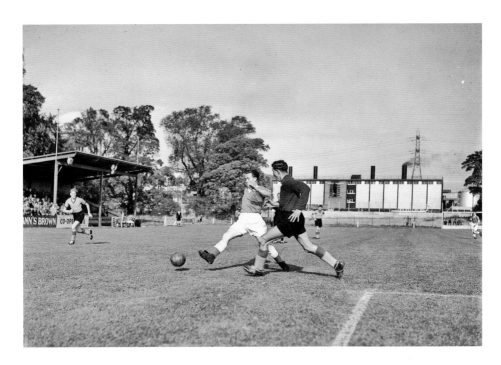

Where the Blues Once Played

Dunstable Town FC moved to its splendid ground at Creasey Park, off Brewers Hill Road, in 1998. Prior to that, matches were played on a former riding school field at Kingsway. This photograph, taken in October 1957, shows a match there between the Town and Vauxhall FC, with part of the old Dunstable Vauxhall factory in the background. The club was formed in 1883 but disbanded after a long and successful career, only to be re-formed in 1950. The Duke's Court/Queen's Court homes stand approximately on the spot today.

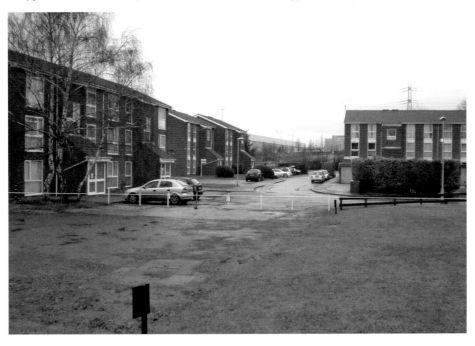

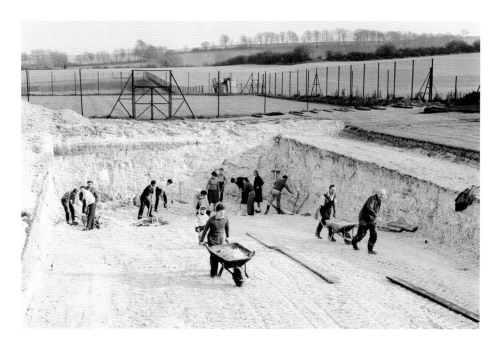

Do-It-Yourself Swimming Pool

Parents and staff provided an open-air swimming pool for Kingsbury School the hard way – by digging it themselves using shovels and wheelbarrows. The picture was taken in April 1961 in the school field from the top of Meadway, with beech trees lining the downs in the background. The pool was filled in after it began to leak in 1999 and the area has been transformed into an environment space, with a pond, beehives and a badgers' sett. Kingsbury School merged with Queen Eleanor's School for Girls when comprehensive education was introduced. The big new establishment was given an appropriately combined name: Queensbury.

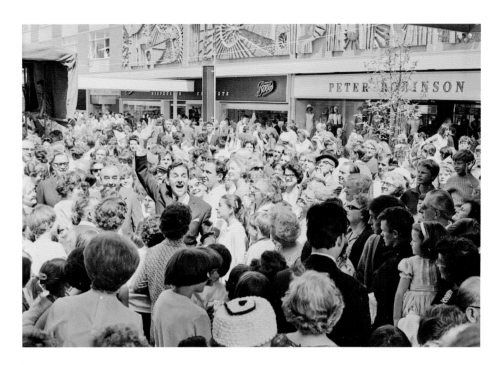

The Late Bob Monkhouse

Comedian Bob Monkhouse, who lived nearby in Eggington, is seen at the opening of the Quadrant shopping centre in June 1966. Its big attraction, unusual for the time, was that it was a pedestrian area away from the high street traffic. In fact, the notorious Dunstable traffic jams caused Bob to miss the opening ceremony, for which the mayor, Cllr Charles Conway, had to make an impromptu speech. The centre has since been redesigned to provide shoppers with shelter from the rain.

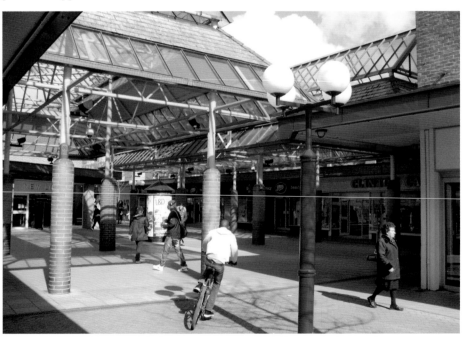

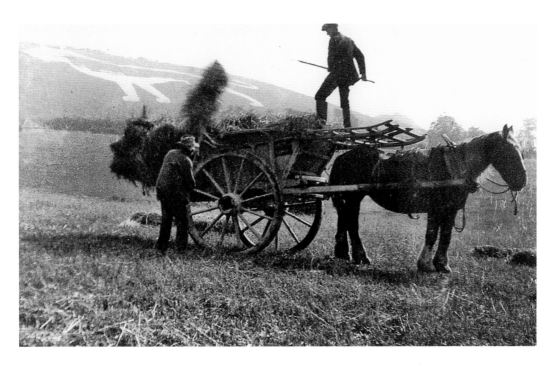

When the White Lion Was Being Cut

Whipsnade Zoo's famous landmark, the white lion cut into the chalk hillside, can be seen in the background of this picture of workers loading hay or straw on to a horse-drawn cart at Valence End Farm. It was taken by amateur photographer Clifford Thompkins and its date can be worked out with some accuracy because the lion was still being carved at the time. Work on tracing the lion's outline began in June 1931 and it was completed by Easter 1933. It is 480 feet long, with a total perimeter of ⅜ mile. Its tail is 13 feet wide.

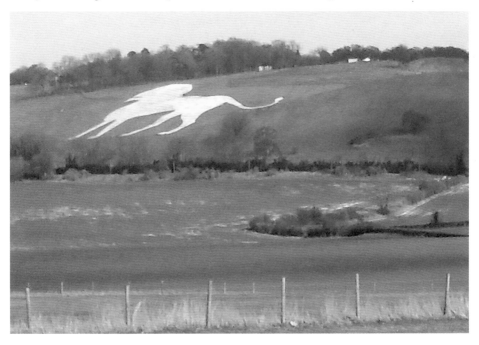

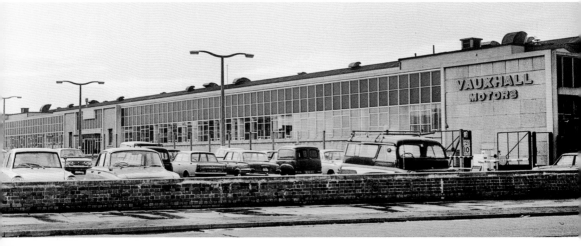

Huge Expansion at Dunstable Vauxhall

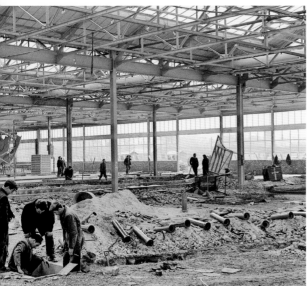

It seemed as though nothing could go wrong. The Vauxhall factory in Boscombe Road, Dunstable, could not cope with the demand for Bedford Trucks and needed to expand. A vast new assembly plant was constructed in the 1950s and, by the mid-1970s, 5,700 people were employed there. But foreign competition was formidable and General Motors closed its Dunstable operation in 1987. The factory reopened under the name AWD, but it closed again in 1992 after a huge order to supply the Libyan Army was blocked by UN sanctions. The site is now occupied by the Sainsbury's superstore, the White Lion Retail Park, and the Superdrug distribution centre, among other businesses.

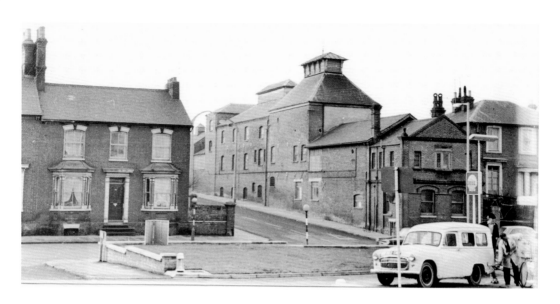

Bennett's Brewery in Chiltern Road

The corner of Chiltern Road and High Street North was once covered by a large brewery owned by Benjamin Bennett. He had bought the business in 1887 and made it a huge success. The brewery was demolished in 1971 and replaced by a pub-restaurant called the Chiltern (later named The Priory). In 2013, the Elliott Court old people's apartments were built on the site. The Northgate filling station, seen opposite the brewery in our photograph, was erected on land where another well-known building, Tower House, once stood. This had been the home of John Dales, owner of the Dales Dubbin factory in Tavistock Street.

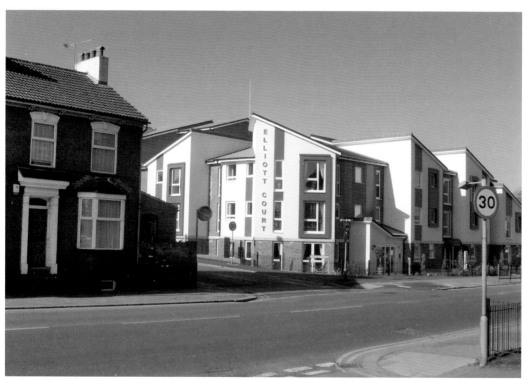

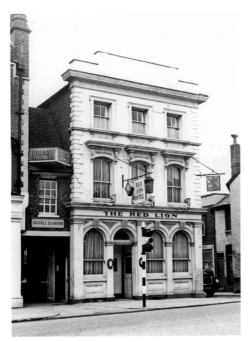

Eat a Dish of Larks at the Red Lion

One of the most famous of Dunstable's many coaching inns, the Red Lion, fell victim to the motoring age. It stood on the junction of two busy roads at the corner of Church Street, where there was room for just one line of traffic to pass through. The picture on the right shows the inn's courtyard, with the landlord, Sammy Bayes, seated. West Street is visible through the archway. There had been an inn on the site since before 1381 but the end came in March 1963 when it closed to allow the road to be widened. In its heyday, the inn's kitchens were famous for dishes of delicious Dunstable larks, thousands of which were netted on Dunstable Downs and cooked to a secret recipe.

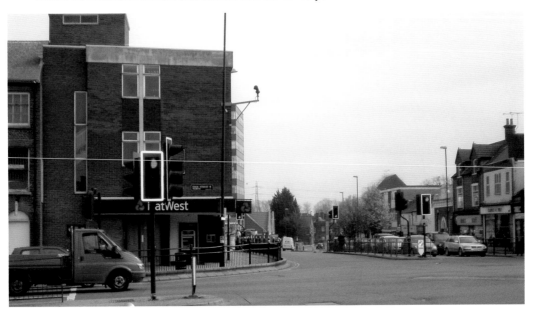

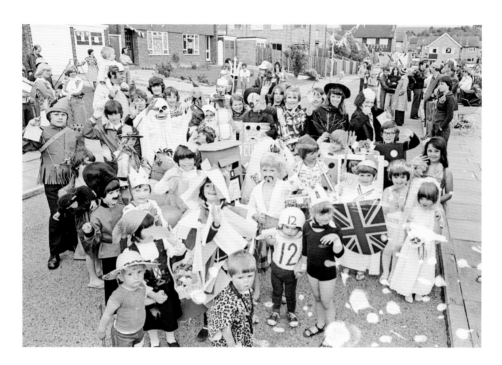

Jubilee Tea at Valence End

Street parties were held all over Dunstable in 1977 to celebrate the Queen's Silver Jubilee. This is a view of the event in Valence End, one of the roads built in 1968 by William Old Ltd. The company tried to find local names for all the streets in its development. Valence End is the name of a farm, once called Valenciennes, on the Tring Road. The colour picture shows Les and Valerie Hill, who have lived at Valence End since it was built and who helped to organise the jubilee party.

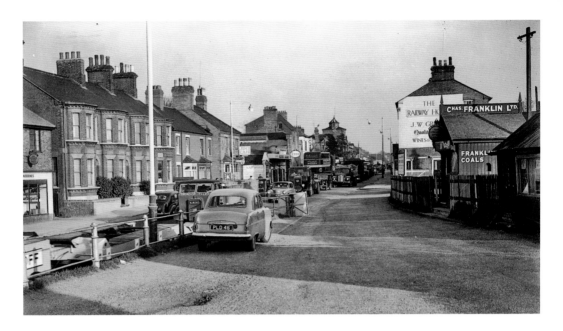

Coal Depot at Dunstable North Station

Franklin's was a well-known coal merchant in Dunstable in the days when almost everyone had a coal fire. Its depot was at the railway station in High Street North, where this photograph was taken in 1955. The firm's wooden office, on the side road leading to the station, is seen on the right of the picture. The road is still in existence, leading nowhere today as the station was demolished long ago. And there are houses and a car park on the corner of Westfield Road, where the Railway Hotel once sold J. W. Green's beers. It closed on 18 December 1973. The tower of Tower House can be seen in the background.

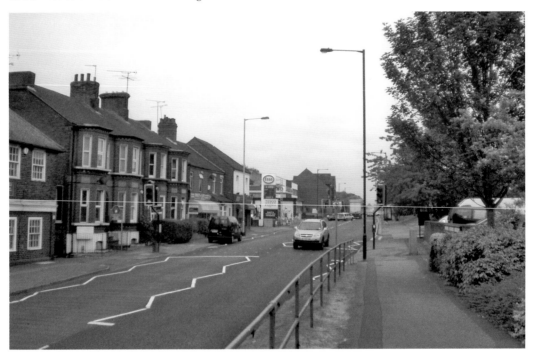

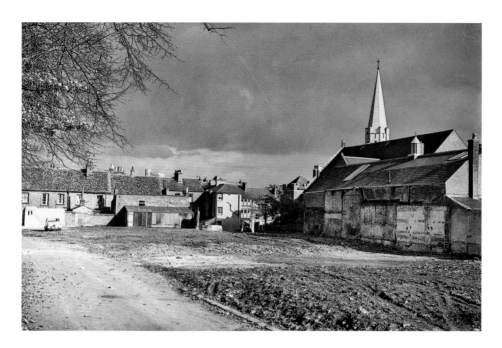

Ready for a New Sainsbury's

An historic part of Dunstable vanished in 1957, when a network of old streets and terraced cottages was demolished in the area behind Middle Row. The Ashton Square shops, including a Sainsbury's store, with a huge (free) car park, were eventually built on the land. This photograph was taken in October 1957 when the streets alongside West Street had been cleared. You can see the familiar spire of the Methodist church in the background. The colour photograph, showing approximately the same view, was taken from St Mary's Gate (the old Cross Street West) near the police station.

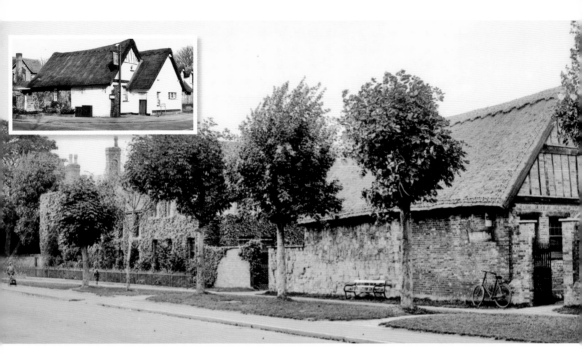

Museum and Library at Kingsbury

The signs in this picture of Kingsbury farmhouse in Church Street advertise the presence of the town's museum and library, which were the brainchild of Thomas Bagshawe, son of the founder of the Bagshawe factory. That dates the photograph as between 1927, when the museum opened in a converted barn, and 1934, when the barn and farm stables were sold to create Kingsbury Riding Stables. The Old Palace Lodge hotel has been created around the centre of the farm complex and the Norman King pub (*inset*), transformed from the old barn and stables, was gutted by fire in 2011.

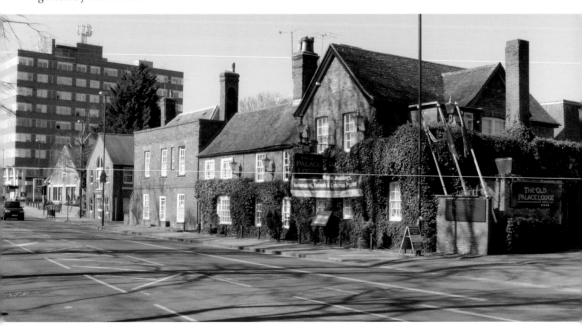

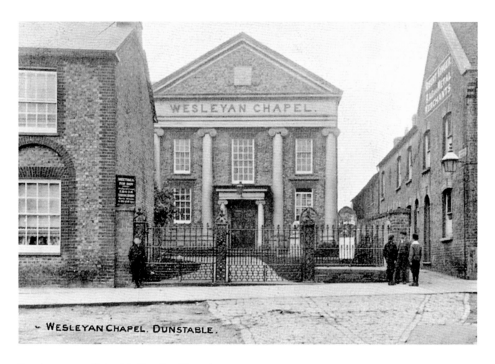

WESLEYAN CHAPEL. DUNSTABLE.

Predecessor of the Methodist Church

Methodists bought land at the Square in Dunstable in 1831 and built a chapel there, only to see it destroyed by fire in 1844. They opened a new chapel on the site the following year, and extended it in 1853. But in 1908 this building, seen in the photograph, also burned down. The resilient congregation replaced it with the present church, with the tall spire, the following year. The rag and metal merchant's building alongside stood on the site of what is now Ashton Square and the shops, which include Wilkinson's.

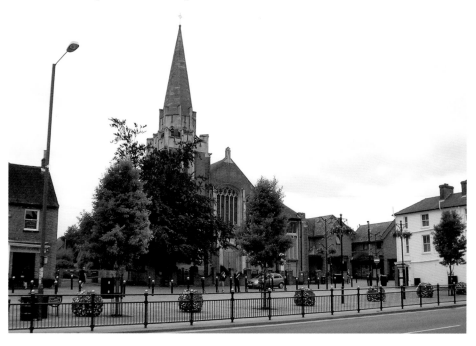

Baptist Chapel Survived

Surviving the bulldozers in 1978 was the old Baptist chapel in St Mary's Street. There had been a place of worship on the site since 1708 and it was unthinkable that it should be destroyed to create a supermarket car park. But the garages for the long-established Costin's Coaches business, seen in the background, were doomed.

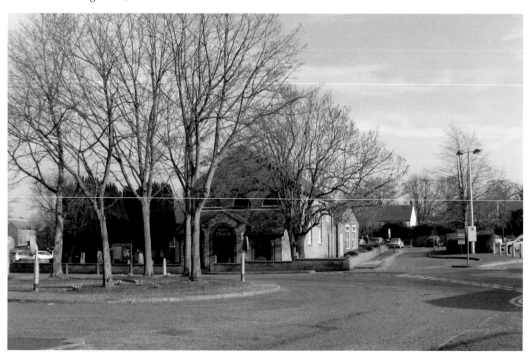

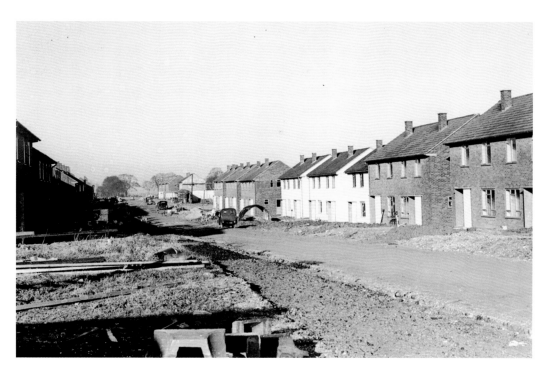

A New Estate Called Downside

Downside estate was in its early stages of construction when this photograph was taken by the *Gazette* in the early 1950s. The road had not been named at that stage but it is readily identifiable today as Mountview Avenue. Some of the houses were built in what was, at the time, an experimental pre-cast design. The white houses in the centre of the picture are fairly distinctive.

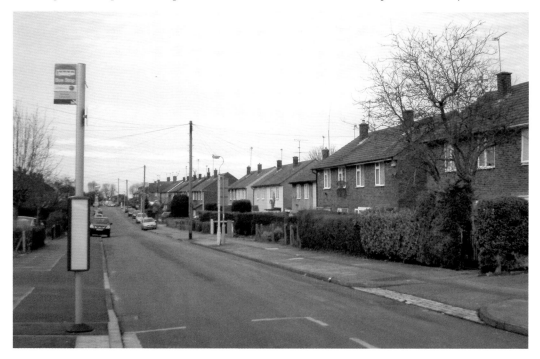

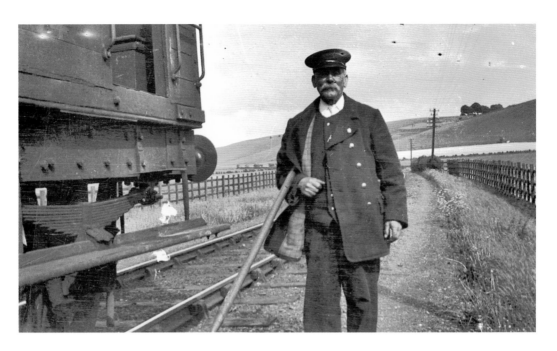

From Railway to Busway

The negative of this photograph of a railwayman is among a small collection of photographs from around 1914 in Dunstable Local History Society's research room at Priory House, Dunstable. It was taken near the railway station in Church Street, Dunstable, with Blow's Downs in the background. The railway track, now the Dunstable–Luton busway (seen in the colour photograph), continued around to the left alongside what is now Jeans Way, past Skimpot, and along to Luton. The line, which opened in 1858, closed in 1967 and flats have been built on the Church Street station site.

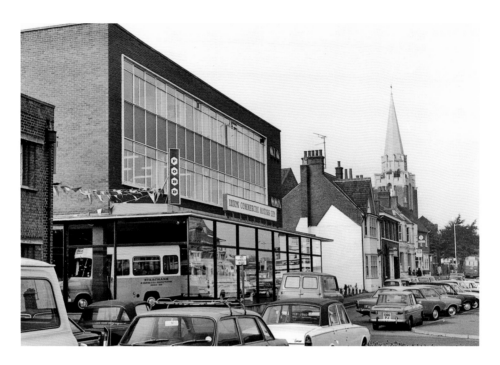

Motor Showroom on the Square

Luton Commercial Motors, whose showroom was at Thames House, on the Square at Dunstable, was one of the town's high-profile businesses in the 1960s and 1970s. The showroom closed in the 1980s and it is now the home of scores of exotic reptiles in Wrigglies, and the Choice Foods convenience store. The familiar sight of the Methodist church in the background easily identifies the location. Joan Vaughan, the business development manager of the company that inherited the motors business, discovered this photograph.

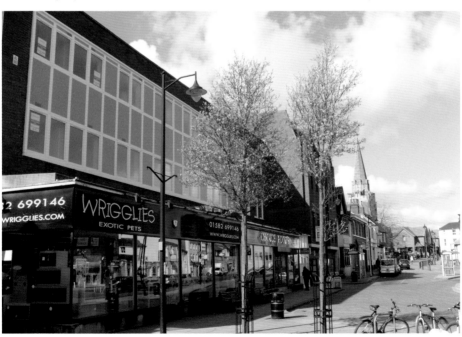

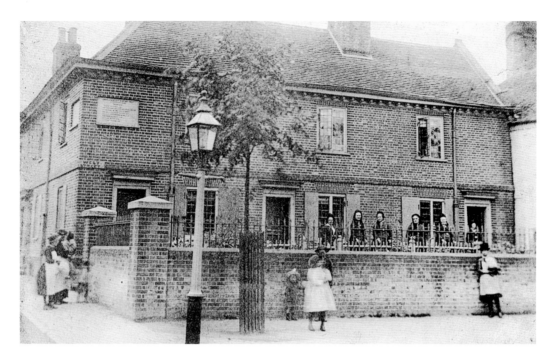

Petticoat Legacy for the Almswomen

The six very respectable ladies who lived in the Ashton almshouses in West Street all appeared in their front garden for this photograph in the 1870s. Mrs Frances Ashton, whose husband made a fortune from sugar plantations in the West Indies, built the houses on the corner of Ashton Street in 1727. Her legacy included money to buy gowns and petticoats, all of the same colour, for the almswomen. Money from the sale of the West Street site was used to build new almshouses in Bull Pond Lane in 1969.

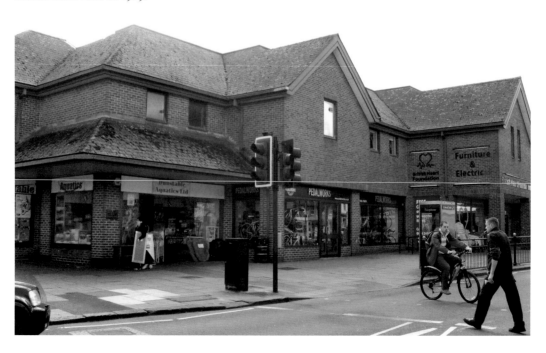

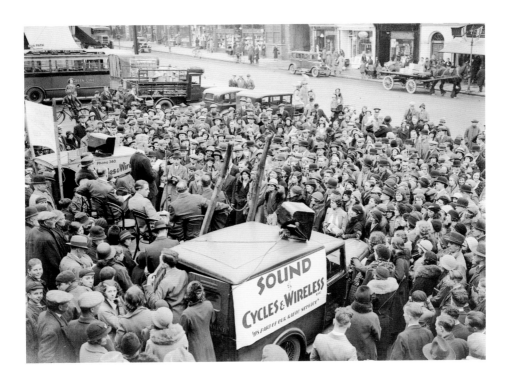

Come to Dunstable ... or Else

An unpleasant shock in 1934 for workers at the AC Sphinx Sparking Plug factory in Birmingham was the news that the firm was transferring to a new plant to be built at Dunstable. They could keep their jobs if they were prepared to move too. Dunstable Borough Council did its best to ease the blow by organising a series of open-day events to demonstrate how happy they would be in Bedfordshire. This the scene at the Square, Dunstable, in April when the mayor, Cllr Alf Cook, made a speech of welcome, using a pioneering public-address system provided by a Dunstable shop, Cycles and Wireless.

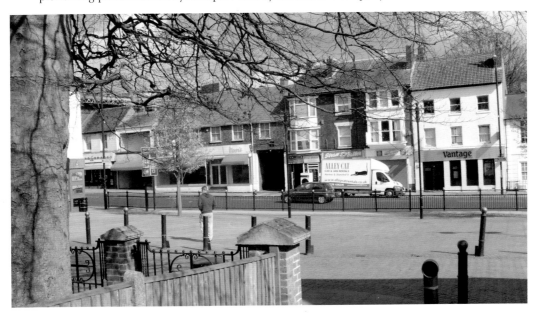

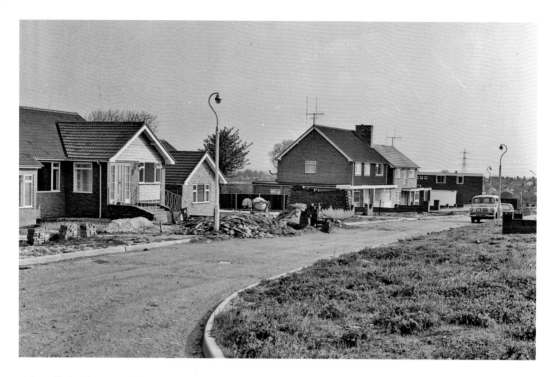

Why Clinker is Found in Furness Avenue

Furness Avenue, Dunstable, was still being built when this photograph was taken, perhaps in 1965, when the road was still unmade. The flat-roofed building in the distance is the Red House, close to the Bull Pond Lane junction. The road stands on the site of the old Harrison Carter engineering works, where the Carter Disintegrator grinding machine was manufactured. That's why clinker, a remnant of the factory furnaces, is often found in the area. One resident has noticed that the plot of land on which his bungalow stands was priced at £1,600 in 1963/64 – quite expensive for the time.

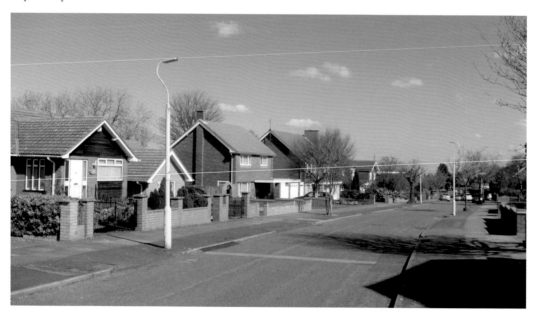

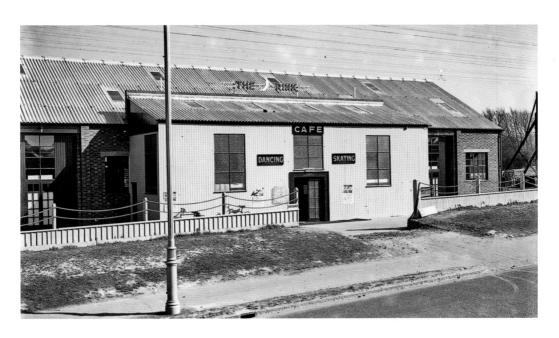

Skates on at the Half Moon

The Half Moon Skating Rink, seen here during the week of its opening in March 1938, was a big attraction in Dunstable. It was built by Aubyn Pratt, son of the owner of Park Farm, whose fields were situated between the Sugar Loaf and the grammar school. The rink, on Half Moon Hill in London Road, stood in the middle of open land at the time. It closed in the early 1960s and the site became a car sales centre, now empty. The colour photograph is taken from the side of the sales showroom, looking towards the eighteenth-century Half Moon Inn.

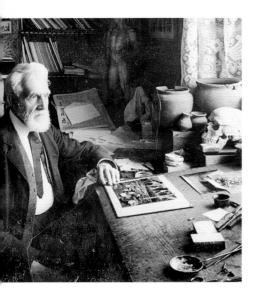
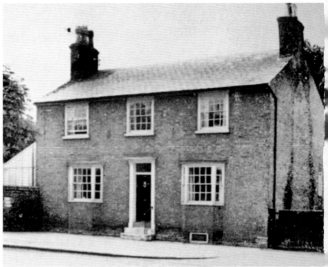

How to Identify Poisonous Fungi...

Hawthorn Cottage, which stood in High Street South until 1959 on what is now the site of the BP petrol station, played an important part in Dunstable's history. It was the home of Worthington Smith, the Victorian artist and archaeologist, seen here in his study. He made numerous discoveries about the town's history and his house became a treasure trove of artefacts. He was a national expert on fungi, increasing his knowledge of which were poisonous by eating small amounts and noting whether or not he felt ill!